HISTORICAL RAILWAYS AROUND THE WORLD

ALON SITON

AMBERLEY

First published 2023

Amberley Publishing
The Hill, Stroud
Gloucestershire, GL5 4EP

www.amberley-books.com

Copyright © Alon Siton, 2023

The right of Alon Siton to be identified as
the Author of this work has been asserted in
accordance with the Copyrights, Designs and
Patents Act 1988.

ISBN 978 1 3981 0832 5 (print)
ISBN 978 1 3981 0833 2 (ebook)

British Library Cataloguing in Publication Data.
A catalogue record for this book is available from
the British Library.

Typesetting by SJmagic DESIGN SERVICES, India.
Printed in the UK.

Introduction

It has been some 200 years since the Industrial Revolution and the creation of the modern railway as we know it today. A relatively short period in history, it nevertheless saw the rise and fall of all of the European empires and the later establishment of the nation state; the brutal carnage of the First World War; the roaring twenties and the Great Depression; the horrors of the Third Reich; Germany's defeat in the Second World War; the Cold War and the formation of the Iron Curtain over eastern Europe; the demise of the Soviet Union and the unification of the two German states; and, on an optimistic note, the start of a new era of relative peace and prosperity, despite a good deal of unresolved disputes, mainly in the Middle East and in Africa. In most cases, it was the railways that were the physical manifestation of nearly every country's political and financial interests, both at home and abroad. To name a few outstanding examples, Britain's domination of India could have only taken place thanks to the giant railway system of the Raj. The railways were vital for the proper running of the European colonies in Africa to such an extent that in Congo's case, the legendary explorer Henry Stanley reported back to King Leopold of Belgium that 'all of Congo isn't worth a penny without a railway', upon his return from Africa. The Ottoman Empire's Hedjaz Railway served a double purpose as a military line that was specifically designed to strengthen the Turkish Sultan's rule in the Middle East, and to carry Muslim pilgrims to the holy city of Medina, in Arabia, for the religious festivity of the Haj. Two other large-scale projects that come to mind, within the context of this discussion, are the Berlin–Baghdad railway, better known in German as the Bagdadbahn, and Cecil Rhodes and his Cape to Cairo railway. Curiously, both of these massive projects were launched before the First World War, and shared a common fate in that they were never fully realized as originally intended. The journey from Berlin to Baghdad at first required not only a considerable change of trains along the way, but a long drive into the desert, on the approach to Iraq, owing to a large gap in the line itself. Similarly, crossing Africa by train from north to south was a combined train, boat and road service, to say nothing of the different track gauges of the railways involved. Taking all that into account, there remains the fact that all of the above-mentioned projects were politically motivated, and were conceived in the name of an official agenda.

The course of history, however, is by no means limited exclusively to such dramatic events as the sinking of the *Lusitania* or the landing on the moon. History could certainly be, and is indeed, often found in life's seemingly small moments. Events that were perfectly trivial back in the day often inspire a nostalgic mood when viewed through the lens of time, decades later. As will be seen in the following pages, this is

precisely what this book is all about. Essentially, it is a romantic journey back in time to far off, foreign lands, and to a bygone world that today still lives on in old photos and maps. A train ride in that old world was a world in itself. One could cross the whole of British India by train to the foot of the Himalayas, with nothing more than a modest 'frontier ahead' sign to mark the place where one empire ended and another began. This was especially true in the years leading up to the Second World War, in that moment in history when the colonial railways of Africa and Asia were at their most advanced. Imagine the stunning view of the Victoria Falls while riding a train behind a Garratt locomotive, or pulling into Baghdad station, even as late as the fifties, behind a beautifully streamlined, Mallard-like Pacific, after covering hundreds of miles in the Iraqi desert in the comfort of an elegant train. Imagine travelling down the Nile, from the shores of northern Egypt, to Luxor, in a fancy Wagons Lits coach, with connection to Khartoum and to Port Sudan. So much was possible back then, so little is left of it today.

It was William Shakespeare who wrote 'Beauty is bought by judgment of the eye'. The railway photos in this book, all painstakingly collected over many years and at great expense, range from British and European steam to tiny local lines in the heart of Africa, and from the formidable mountain ranges of South America to the equally impressive Canadian Rockies. In a manner of speaking, there is a flavor for everyone's taste, be it steam, diesel or electric locomotives. Official works photos share room with privately made pictures. Let the journey begin.

For their help and support in the making of this book, and for offering me useful and valuable information, I wish to thank Colin Alexander, Connor Stait, Greg Martin, Helmut Dahlhaus and Julian Rainbow.

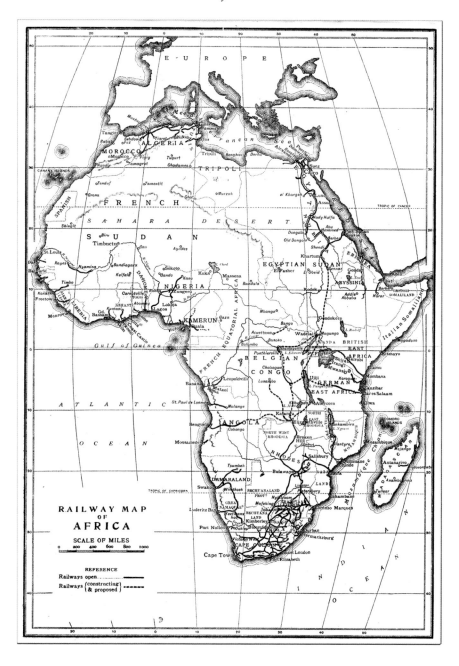

Cecil Rhodes envisioned a Cape to Cairo railway. This colonial-era map of the main railway lines in Africa, published before the First World War, clearly demonstrates the proposed route, which would have covered thousands of miles across eastern Congo, Sudan and other African territories. Ultimately, a combined road, rail and riverboat service was established, replacing the original plan that proved impractical in part due to the break of gauge with Egypt's standard gauge system. In contrast, the Benguela Railway provided a direct link between western Africa, Rhodesia and South Africa. Above and below French Sudan and the Sahara Desert, shorter lines were built to connect the African coastline with the inland communities.

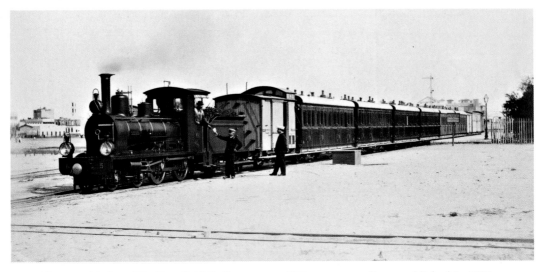

Above and below: The Port Said Railway was a 750 mm gauge line established in 1891 to connect the city of Ismailia with Port Said, in northern Egypt. The PSR's modest fleet consisted of eight steam locomotives, of whom five are known to have been sold off to the Egyptian Delta Light Railways when the line was upgraded to standard gauge in 1904. These were Nos 1–2 (0-6-0 – Corpet Louvet 532–3, 1891), V1–4 (2-4-0 – SACM Graffenstaden 4458–61, 1893), V5 (4-4-0 – SACM Graffenstaden 4675, 1896) and V6, an additional 4-4-0 from 1898. Depicted in this captivating pair of photos are PSR V2 and V5, showing also the mixed traffic trains that were typical of many pre-1914 railway lines.

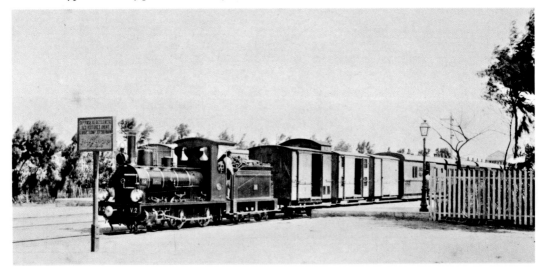

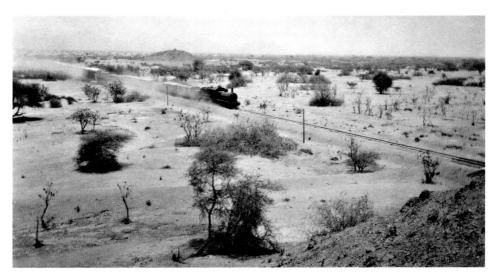

Kicking up a cloud of dust as it rushes through the desert is an Egyptian State Railways steam locomotive, with a mix of passenger and freight cars. Of considerable nostalgic value, this photo conveys a powerful impression of the train's force and speed in the empty desert.

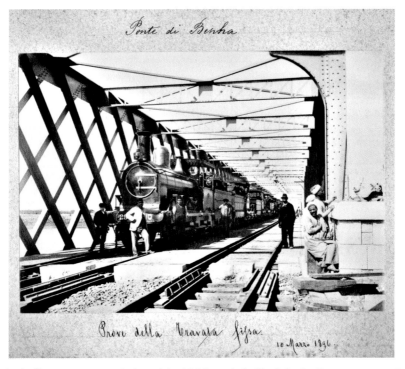

An original album was commissioned in 1896, on behalf of the Italian contractor Impresa Industriale Italiana di Construzioni Metalliche, to commemorate the construction of new railway bridges on the Cairo–Alexandria main line. This photo, dated to 10 March, shows the new Banha Bridge, in the Nile Delta, being tested under the weight of several Egyptian steam locomotives. The leading locomotive, No. 295, was a 0-6-0 delivered in 1893 as part of a large order placed with Franco Belge.

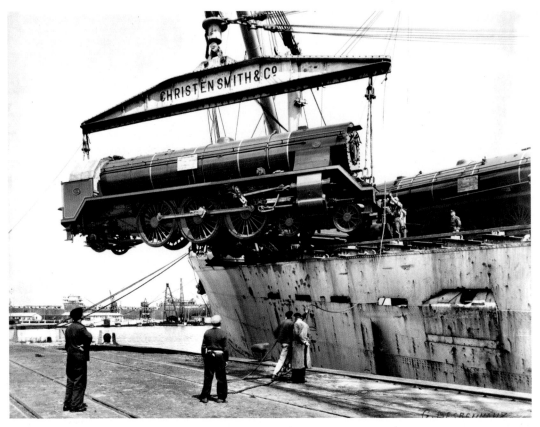

Above: The last steam locomotives ever built for Egypt were French-built 4-6-2s, here seen being shipped to Alexandria in 1954. These twenty Société Alsacienne de Constructions Mécaniques Grafenstaden locomotives became ESR 101–120 (SACM 8159–8178, 1954). By all accounts they were excellent machines. However, they were all retired within only a few years, with the transition to diesel power in Egypt. All were scrapped.

Opposite above: A First World War photo showing two Baghdad Railway steam locomotives in Egypt. The serviceman behind is in British (other ranks) uniform and the other, to the right, is wearing an Australian slouch hat with a feather in it, which was typical of the Australian Light Horse uniform. Four 2-6-0 locomotives were built in Germany by Hanomag in 1914 for the Bagdadbahn, under the works numbers 7324–7328. They were captured on high seas in 1915 and transferred to the Egyptian State Railways. Originally numbered 626–630, they became ESR 102–105. Their 1924 numbers were ESR 217–220 and in 1926, 501–504. This is the only known privately made photo of these locomotives in Egypt.

Opposite below: Serving as the background for the statue of King Ramses II, the main entrance to Cairo Pont Limoun station is a splendid blend of Islamic and Moorish architecture. The statue itself was relocated to Giza, outside Cairo, in 2006, in preparation of entering the Grand Egyptian Museum. Traffic in 'Boon Limoon' is limited to local and suburban trains. Long-haul trains reach Ramses station (now called Misr), which was inaugurated in 1925 and is only a short walk away from Pont Limoun.

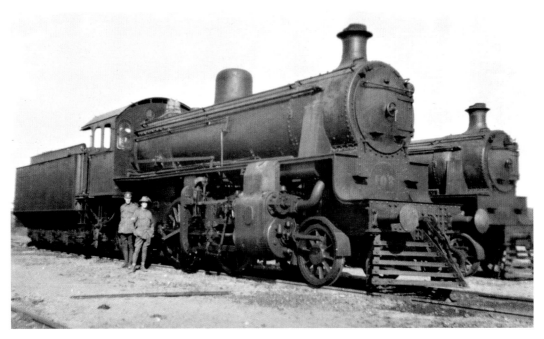

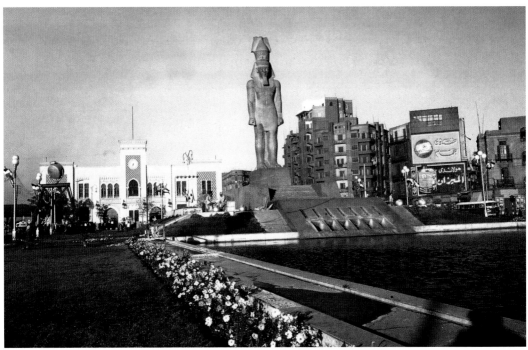

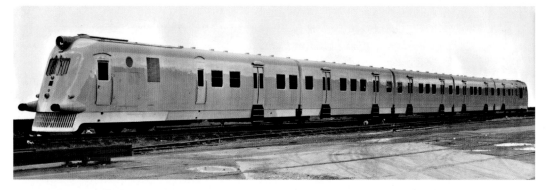

In 1950 the English Electric Company received an order from the Egyptian State Railways for articulated diesel-electric multiple units. These were supplied together with Birmingham Railway Carriage & Wagon (BRCW) of Smethwick coaches. Ten five-coach trains were built for the Cairo–Alexandria high speed service, along with nine similarly looking suburban sets. This is an official works photo of one of the new suburban trains.

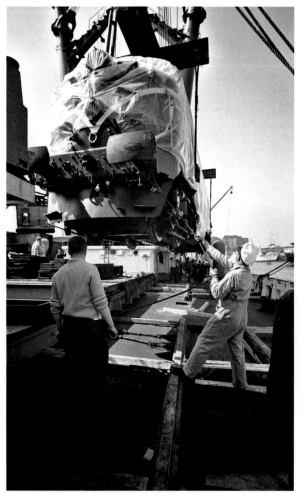

Egypt's good business ties with Henschel of Kassel go as far back as the beginning of railways in that country, ranging from steam to diesel locomotives of every size and shape. Following an order for twelve mainline diesels from English Electric and Vulcan Foundry in 1948, additional and larger orders were placed with Henschel and General Motors for freight and passenger diesels. Seventy Class AA12 Bo-Bo locomotives arrived from Germany in 1960–61, rated at 1,310 hp and using General Motors parts and technology. In Egypt, they carried the road numbers 3601–70. A member of that class is seen carefully hoisted and placed aboard the ship that would carry it from Europe to Africa.

Official portrait of a self-propelled turbo train for the Egyptian National Railways. This train was built in France by ANF Industrie in 1981 and was one of three ten-car trains for a planned high speed (160 km/h) service on the 208 km route between Cairo and Alexandria. However, the line was unsuitable for such speeds, and the trains were restricted to a top speed of 140 km/h and 60 km/h in the vicinity of Cairo. By 2011, all three trains were retired and scrapped. ANF (Ateliers de Construction du Nord de la France) was a locomotive manufacturer, based at Crespin in the Arrondissement of Valenciennes, in northern France. Later known as ANF Industrie, the company was acquired by Bombardier Transportation in 1989 and is now part of Bombardier Transport France.

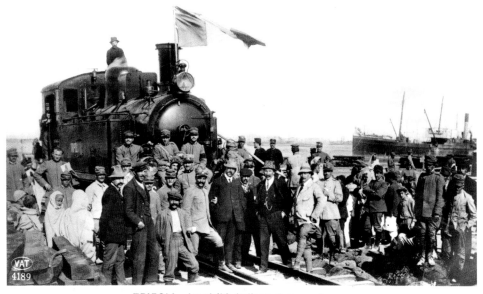

TRIPOLI - La civiltà Italiana si avanza!

Egypt's economy has always depended on a fully developed railway system. The same, however, could not be said of Italian-ruled Libya, with its few short lines and no international routes. Libya's first railway was a 950 mm gauge line constructed after the Italian conquest of Tripoli in 1911. The first section was completed a year later, in 1912, from the Port of Tripoli to Ain Zara, totaling 11 km. Starting in May 1913, all railway operations in Libya came under the Italian management of the Ferrovie dello Stato and were officially called Società Nazionale per le Ferrovie Coloniali Italiane (Libia). This photo records the arrival of steam locomotive No. 203 *TRIPOLI* (Schwartzkopff Locomotive Works, Berlin 4009, 1908) to the Port of Tripoli in 1912, with the caption 'TRIPOLI – La civilta Italiana si avanza!' It was in fact one of twelve 0-8-0s that were supposed to run in Sicily, but ended up in Libya.

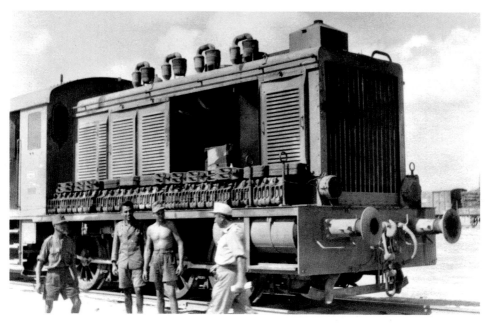

The German military advance into North Africa in the Second World War was carried out by the Deutsches Afrikakorps (German Africa Corps, or DAK). Originally dispatched to Africa to assist the Italians in the defense of their colonies, this expeditionary force fought on in northern Africa from March 1941 until its surrender in May 1943. The Germans operated several diesel locomotives under the title Eisenbahn Betriebsführung Tobruk as part of their war activities in the deserts of Libya and Egypt. This pair of photos, taken privately in 1942, shows Wehrmacht Regelspur Class WR360C14 diesels, either in the Libyan or Egyptian desert. It did the Germans no good, least of all when some of their locomotives were captured by the British, given new War Department road numbers, and sent up north to haul British military trains in Lebanon.

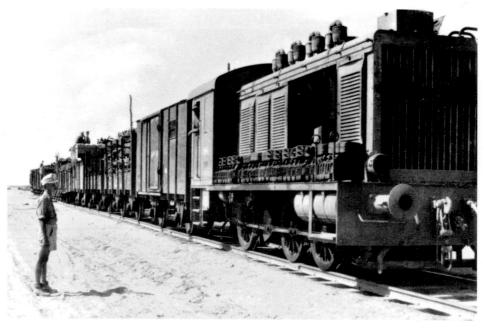

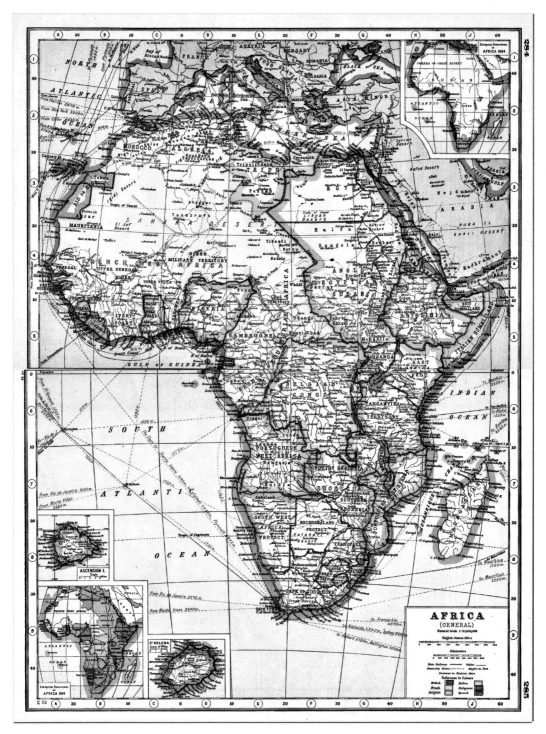

Colonial Africa before the First World War.

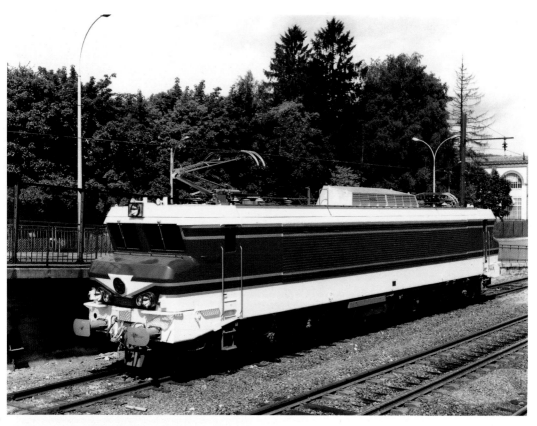

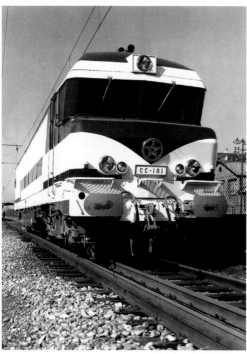

Left: Another example of Nez cassés locomotives in Morocco is CC-101, the diesel version delivered in 1968. Modeled after the French CC 72000, the class is used in both passenger and freight traffic and was even enlarged in 2007 with six more ex-SNCF units, bringing the total to twenty locomotives. With their attractive color schemes, the Moroccan locomotives are easily some of the prettiest examples of the 'broken nose' school of design.

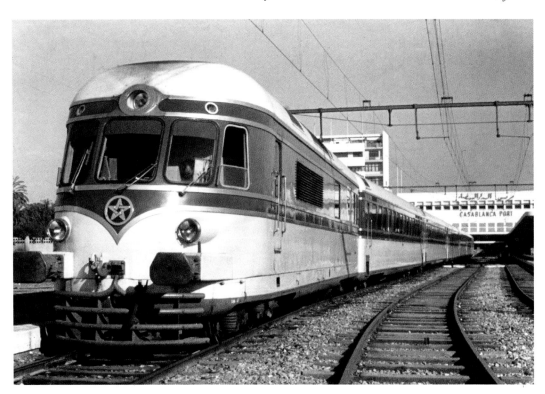

Above: In 1956, Morocco ordered eight new, air-conditioned Class XDD diesel trains from Alsthom and de Dietrich as part of a comprehensive fleet modernisation plan. The trains were only delivered in 1961 and consisted of two powered cars with five intermediate coaches (three first and two second class). Designed for a top speed of 140 km/h, the trains were originally intended for the night service to the Port of Oran (Algeria), in connection with the maritime link from France and Casablanca. Due to Morocco's independence, this service was withdrawn and the trains remained in France until 1961. They were then used on express day trains between Casablanca and Tangier, in a formation of two powered cars and up to five coaches (180–200 seats). They were also used as royal trains, until finally retired in 1975. This official photo shows an XDD diesel train at the Port of Casablanca.

Opposite above: The former French colonies in North Africa – Morocco, Algeria and Tunisia – retained a measure of French character, despite the political differences with France, even in the post-independence years. The Chemins de Fer Marocains are a good example of this policy. In 1970, seven electric locomotives, numbered ONCF E901–7, were ordered from Alsthom with a top speed of 125 km/h. A derivative of the SNCF Class CC 6500 model, the E900 came from a large family of diesel and electric locomotives commonly referred to as 'Nez cassés' ('broken nose'), the hallmark of the celebrated French industrial designer Paul Arzens (28 August 1903–2 February 1990).

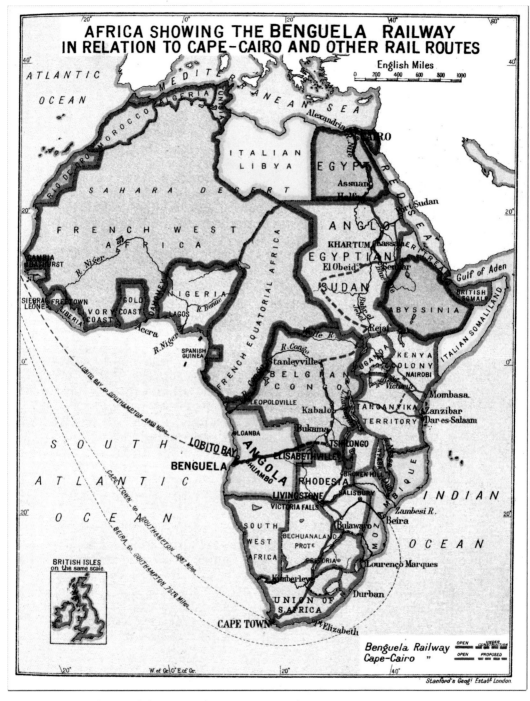

Benguela Railway and the proposed Cape to Cairo railway.

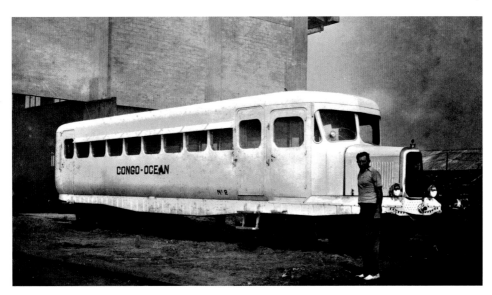

The Chemin de fer Congo-Océan (Congo-Ocean Railway or CFCO) is a 1,067 mm gauge line linking Pointe Noire with Brazzaville, a distance of 502 km, and bypassing the Lower Congo River rapids. From Brazzaville, river boats sail up the Congo River. It was constructed in 1921, through the French Colonial Administration and using forced labor from Chad and the Central African Republic. Loss of life was heavy and, by 1934, some 17,000 African workers were killed in countless accidents and due to malaria. The CFCO closed down temporarily in 1997, during the Congolese civil war, for six years. The service was renewed irregularly despite the poor track condition and a new passenger train, 'La Gazelle', was introduced in 2012, running between Pointe Noire and Brazzaville every other day, and taking up to sixteen hours for the long journey. CFCO railcar No. 2 was built in 1934 with a 105 hp Panhard petrol motor. It carried a total of eighteen passengers and was used chiefly in the Brazzaville area.

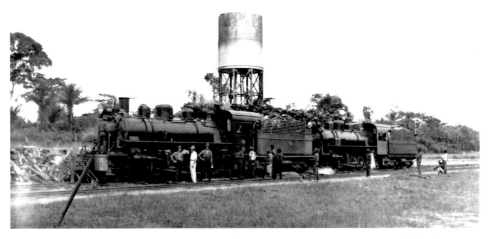

The 1,067 mm gauge Chemin de fer du bas-Congo au Katanga (BCK) was established in 1906 as Congo's main railway company, running rubber and ivory trains first in the Congo Free State and, later on, in Belgian Congo. It was taken over by the Kinshasa–Dilolo–Lubumbashi Railway (KDL) in 1970. Two wood burning 2-8-2s are seen at Mweka (today in the Democratic Republic of Congo, on the Kasai River). The leading locomotive is No. 402 (Haine Saint Pierre 1599, 1928).

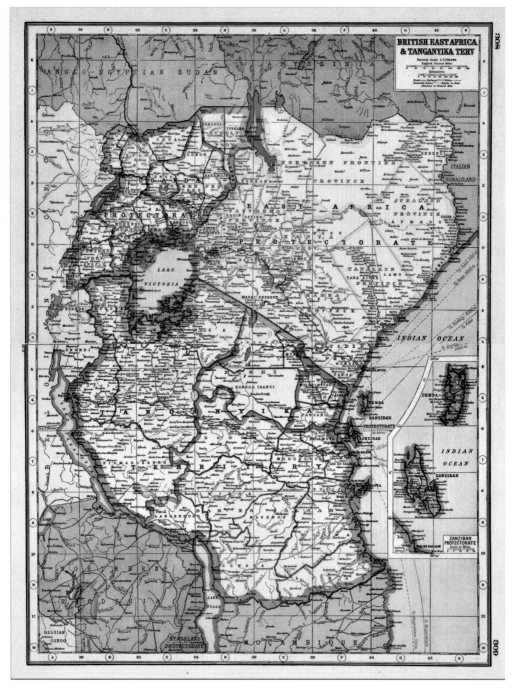

British East Africa and the neighboring colonies.

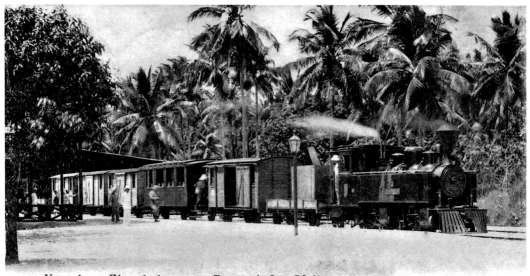

Usambara-Eisenbahn Deutsch-Ost-Afrika.

The first railway ever built in what back then was German East Africa, and has since become Tanzania, was the meter gauge Usambara Railway (Usambarabahn in German). The company owned five Mallet type 0-4-4-0T steam locomotives, built in Germany by Arnold Jung in 1900 (Jung 414–418). Additional steam locomotives were three 0-4-2Ts delivered in 1893 by Vulcan of Stettin (Vul. 1343–45), and from Orenstein & Koppel of Berlin four 2-8-0s in 1908–09, two 0-6-0Ts in 1910, and finally four more 2-8-0s in 1910 and 1912.

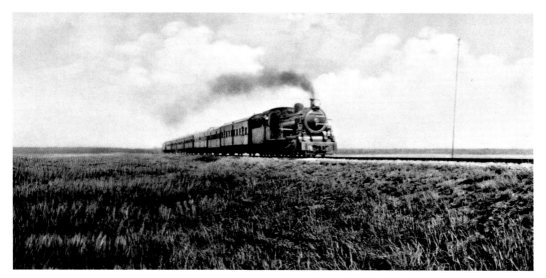

The second railway in German East Africa was the Mittellandbahn, or OAEG. The railways in GEA became the Tanganyika Railway from 1 April 1919, after the First World War, under British mandate. Construction began in 1905 from the port and capital of that time, Dar es Salaam, overcoming massive land obstacles as well as the tropical climate. Kigoma, a point on Lake Tanganyika located at a distance of 1,252 km inland, was reached in 1914 shortly before the First World War. The line provided a new trade route between Lake Tanganyika and the coastline, and was further developed after the British takeover of East Africa. This photo shows the Tanganyika Railway mail train, with a G Class 4-8-0 steam locomotive.

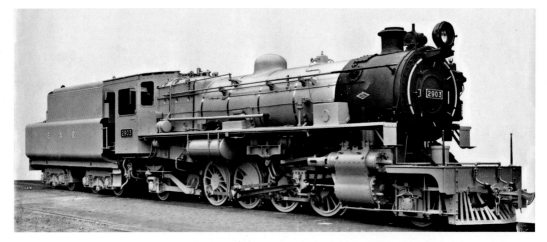

Official North British Locomotive Works (Glasgow) photo of East African Railways 29th Class steam locomotive No. 2903 *Bunyore* (NBL 26907, 1951). It was one of thirty-one oil burning, meter gauge 2-8-2s that were based on the Nigerian Railways River Class. All of the locomotives were named after East African communities. Two locomotives, No. 2921 *Masai of Kenya* (NBL 27436, 1955) and No. 2927 *Suk* (NBL 27442, 1955) were preserved, the first at Nairobi Railway Museum and the second in Dar es Salaam.

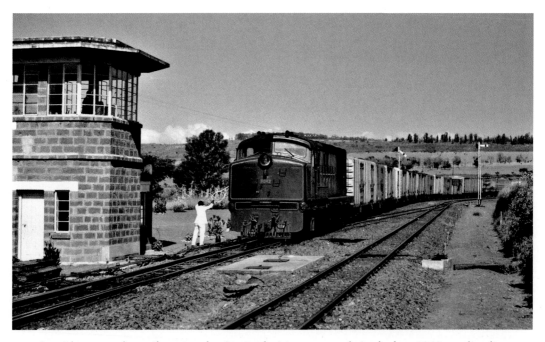

As with many other railways at the time, a decision was made in the late 1950s to dieselize the East African Railways. The first such mainline locomotives appeared in 1960 and came to be known as Class 90 (later renumbered into Class 87). On a clear day in 1969, the driver of a freight train pulled by EAR No. 9042 (English Electric & Vulcan Foundry, 1968) is exchanging the token with the signalbox operator at Nakuru Junction, on the Kampala–Nairobi line.

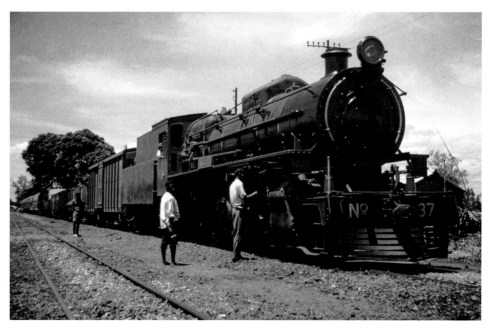

The British Central Africa Protectorate (BCA) was proclaimed in 1889 and occupied the same area as the present-day State of Malawi. It was renamed Nyasaland in 1907, three years after the inauguration of the Shire Highlands Railway, which was the first colonial railway in that part of Africa. The Nyasaland Railways Company was established in 1930 through the merger of the SHR with the Central African Railway. Seen at Luchenza station, to the south-east of Blantyre in 1962, is Class G No. 37 *ROBERT LAWS*, the second of six North British 2-8-2s built in 1949 under the NBL works No. 26749.

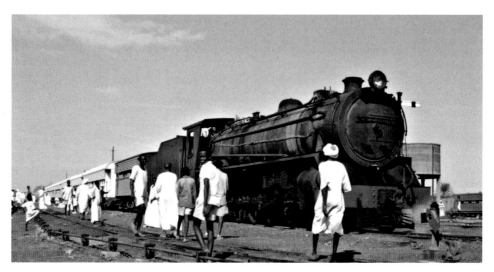

Sudan's heydays as a popular holiday destination are all gone, following years of political instability, civil war and, sadly, the rapid decline of the country's once excellent railway system. The final steam locomotive orders for Sudan, nineteen 2-8-2s in 1952 and 42 4-8-2s in 1955, all went to North British of Glasgow. No. 509 (NBL 27234, 1955) was relatively new when this photo was taken, but unlike the white coaches behind it, is already showing signs of neglect.

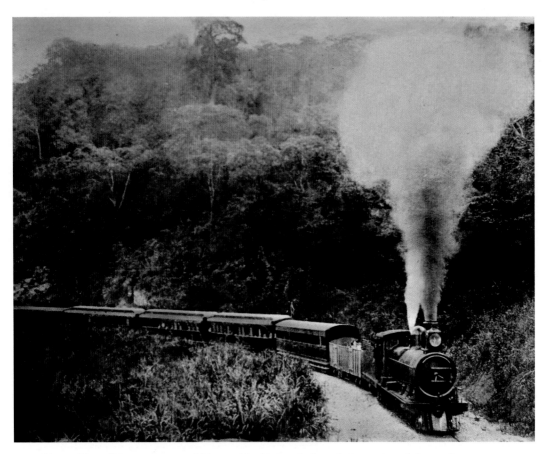

Above: Glass slides were once widely used in the days before the invention of the modern camera. This colorized magic lantern slide, attributed to A. F. Conquer, shows the Zambezi Express train. Mr Conquer was a British government official in South Africa, Rhodesia and Kenya. Of the train, it has been noted that by June 1905, three passenger trains a week were running between Bulawayo and Victoria Falls. The Rhodesia Railways timetable described the Zambezi Express as a through train from Kimberley to Victoria Falls, which completed the 450 km trip in eighteen hours, fully equipped with bedding services and a dining car.

Opposite above: The Caminho de Ferro de Benguela (Benguela Railway) was established in 1905 with the aim of linking western Africa with the rest of the continent. Built to the cape gauge of 1,067 mm, the line commenced from the Port of Lobito and proceeded due east to Dilolo and Tenke Junction, in Congo, where it connected with Rhodesia. A successful railway, it was reportedly operated exclusively by steam locomotives up to the 1970s. The Benguela Railway was damaged heavily in the Angolan civil war and fell into disuse. It was recently rehabilitated with Chinese support, once more serving freight trains from Congo to Lobito.

CFB 11th Class No. 404, seen here in 1973, was the fourth of six 4-8-2 locomotives (North British 26959–64, 1951) designed for use on express mail trains. Three were used on the coast, and another three on the Silva Porto–Luau section until retired in 1974. It was written off in an accident in the early 1970s, along with another locomotive, CFB Beyer Garratt No. 345. The remaining five locomotives were last seen out of service in 1981.

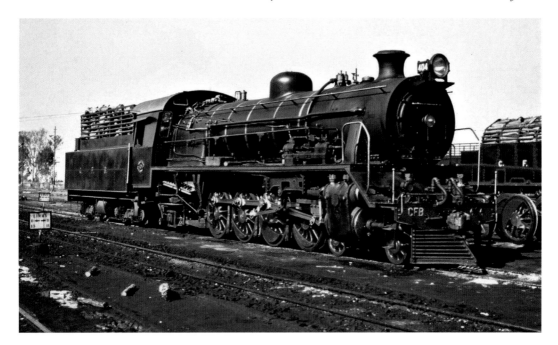

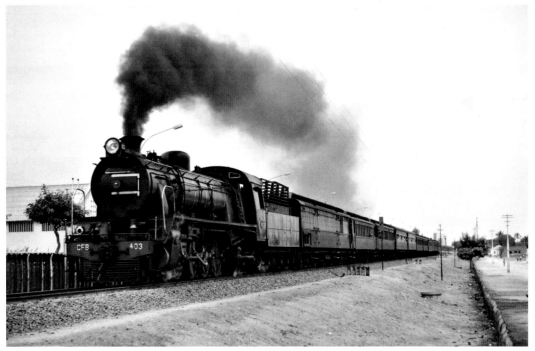

A passenger train on the Benguela Railway in October 1973. No. 403 was the third of six North British Locomotive Company 4-8-2s built in 1951, and sister locomotive of No. 404 in the previous photo. Only two years later, in 1975, a violent civil war broke out in Angola, disrupting all railway operations and extensively damaging the Benguela Railway.

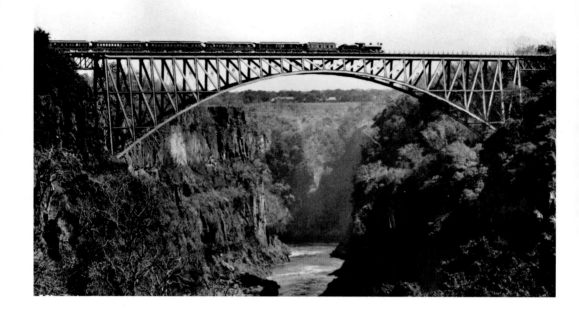

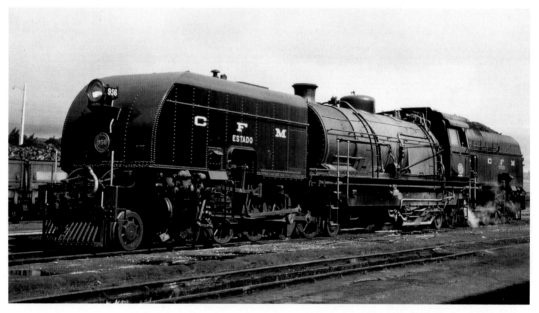

In the former Portuguese colony of Mozambique, the Caminhos de Ferro de Moçambique system is composed of nearly 3,000 km of narrow gauge (1,067 mm) lines reaching into several other neighboring countries. CFM steam locomotive No. 956 (Haine St. Pierre, 2064) was a part of an order for twelve new 4-8-2+2-8-4 Beyer Garratt type locomotives from 1951. They became CFM 951–962. Five more new Garratt locomotives arrived from Henschel of Kassel in 1956 (CFM 971–5), thereby reaching the grand total of fifty-one Garratt locomotives, which were partly acquired in Rhodesia, South Africa and Congo.

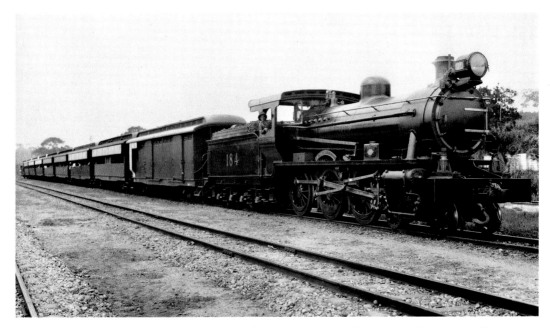

Above: Once one of Britain's smallest African colonies, Gold Coast (today named Ghana) stretched over a total area of 91,690 square miles and was in fact 3,000 square miles bigger than all of Britain. The colony's 1,067 mm gauge railway system roughly resembled a large capital 'A' and has historically been confined to the plains underneath and to the south of the mountains above the city of Kumasi. In a classic colonial-era photo, steam locomotive No. 184 *Sir Matthew Nathan* heads a Gold Coast Railways passenger train. It rolled out of the Robert Stephenson Locomotive Works in 1924 under the works number 3884, with four other 4-6-0s (Gold Coast Railway 181–185/RS 3881–85).

Opposite above: No railway book can be considered complete without a photo of the magnificent Victoria Falls Bridge, over the mighty Zambezi River, which nowadays forms the border between Zimbabwe and Zambia. The steel bridge was prefabricated in England by the Cleveland Bridge & Engineering Company. It was then shipped to the Mozambique port of Beira and transported by train to the Victoria Falls. Completed in only fourteen months and opened on 12 September 1905, the bridge is 198 meters long, and its main arch spans 156.5 meters at a height of 128 meters over the river. Being an engineering wonder, the American Society of Civil Engineers has listed the bridge as a Historic Civil Engineering Landmark. A Rhodesia Railways 8th Class 4-8-0 steam locomotive leads a train of clerestory coaches across the bridge.

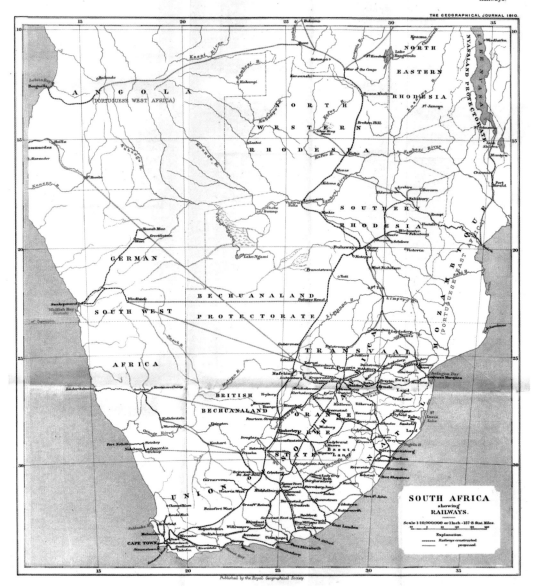

South African Railways map (1910).

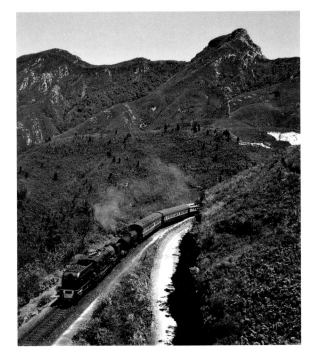

The stunning scenery of the Western Cape's Outeniqua Mountains serves as the background for this breathtaking view of a South African Railways Class GMA/M Garratt locomotive with a passenger train from Oudtshoorn to Mossel Bay, over the Montagu Pass, in 1975.

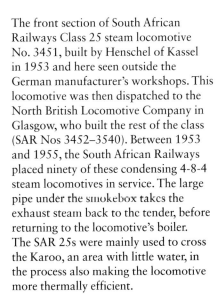

The front section of South African Railways Class 25 steam locomotive No. 3451, built by Henschel of Kassel in 1953 and here seen outside the German manufacturer's workshops. This locomotive was then dispatched to the North British Locomotive Company in Glasgow, who built the rest of the class (SAR Nos 3452–3540). Between 1953 and 1955, the South African Railways placed ninety of these condensing 4-8-4 steam locomotives in service. The large pipe under the smokebox takes the exhaust steam back to the tender, before returning to the locomotive's boiler. The SAR 25s were mainly used to cross the Karoo, an area with little water, in the process also making the locomotive more thermally efficient.

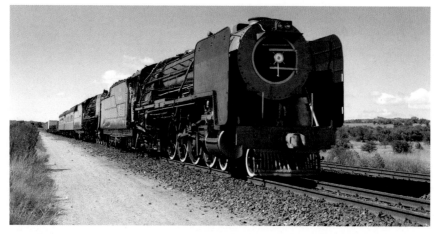

Smartly prepared by Capital Park depot, a pair of South African Railways Class 15F
4-8-2 locomotives (No. 3127 – paired with an EW type twelve-wheeled tender from
a withdrawn Class 23 locomotive – and No. 3099) head a special working over the
Pretoria–Pietersburg route in 1981. They were built by the North British Locomotive
Company under the Hyde Park (Glasgow) works numbers 26011 (1947) and 25983
(1947) respectively.

A series of color photos was commissioned to record the construction of new Henschel
steam locomotives for the South African Railways. SAR Class 23 No. 3242 was
photographed inside the manufacturer's own Kassel works. It carried the works No. 24196
and belonged in the first batch of German-made 4-8-2s ordered from Henschel and
Berliner Maschinenbau Schwartzkopff in 1938 (SAR 2552–2571). A further 116 Class 23
locomotives were ordered even before the first batch could be delivered and tested, owing
to the deteriorating political situation in Europe and particularly in Germany. Of the
second batch, Henschel delivered eighty-five locomotives (SAR 3201–85) and Berliner
another thirty-one (SAR 3286–16). The last locomotive of the second batch arrived in
August 1939, one month before the outbreak of the Second World War.

Between 1935 and 1937, the South African Railways placed a total of forty-four Class 15E 4-8-2 steam locomotives in service. They were built by three different manufacturers. First in 1935, Robert Stephenson & Hawthorns delivered twenty locomotives (RSH 4090–4109/SAR 2858–2877). Henschel of Kassel built sixteen locomotives in 1936 (H 23000–23010, 23111–23115/SAR 2878–2893). Finally, a third batch of eight locomotives arrived from Berliner Maschinenbau (Schwartzkopff 10585–10592/SAR 2894–2901). They were originally used on the main line between Cape Town and Beaufort West, and were then sent up north to De Aar. All were withdrawn from regular service in 1973 except for SAR 2878, which was kept in running order for excursion trains. SAR Class 15E No. 2896 (Schwartzkopff 10587) was photographed outside the German manufacturer's workshops in Berlin in 1936, having been decorated with the South African flag on each side of the headlight. (DRISA photo P2166).

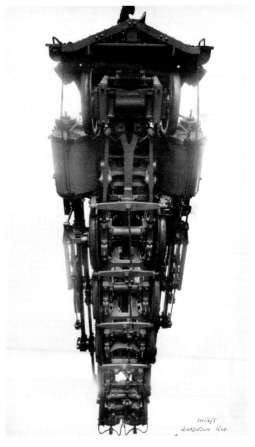

The enormous size of the Beyer Garratt steam locomotive becomes clear in this unusual perspective, showing one third of the underside of such a locomotive. This is a Rhodesia Railways Class 16A 2-8-2+2-8-2, fifteen of which were built by Beyer Peacock of Manchester-Gorton in 1952 (BP 7498–7512), with another fifteen added in 1953.

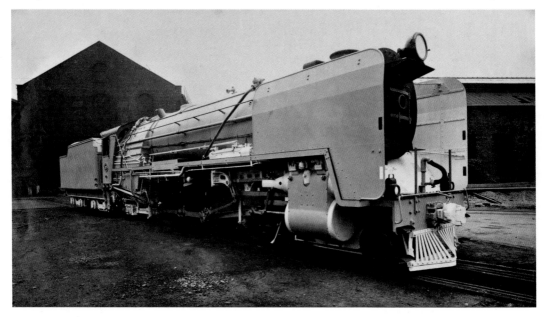

Seen in full splendor and in mint condition, South African Railways Class 15F No. 2971 is ready to begin the journey to its new home in distant Africa. This impressive 4-8-2 steam locomotive was also built by Beyer Peacock in 1944 (BP 7087). The 255 locomotives of the class arrived partly from Britain (Beyer Peacock and North British) and partly from Germany (Henschel and Berliner Maschinenbau), before, during and after the Second World War. Several members of this class are preserved in running condition. No. 3007 (NBL 25546, 1945) is on static display at the Riverside Museum in Glasgow.

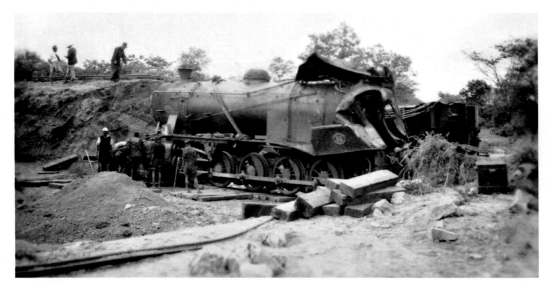

The only known photo of Rhodesia Railways 9th Class steam locomotive No. 85 (North British Locomotive Works 19748, 1912) immediately following a derailment near Colleen Bawn, Matabeleland (144 km to the south-east of Bulawayo, today in Zimbabwe) on 1 January 1948. The accident happened due to an embankment collapse, following heavy rains, killing both the driver and the fireman.

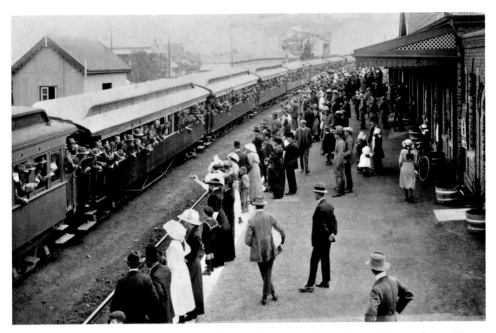

In South Africa, the Hex River Pass is high up in the mountains to the north-east of Cape Town. On 11 September 1914, it was the scene of what has since then become known as the Hex River Disaster. Commemorating the tragedy, a stone obelisk was erected close to the accident site. It is inscribed with the names of the men of the Kaffrarian Rifles, whose troop train rolled off the tracks here, with a catastrophic loss of life. Ten soldiers were killed and 103 were injured when, at 2 a.m., their train rolled downhill with such speed that it fell down the slope. This photo is believed to show the doomed troop train, prior to departure on its fateful voyage and ultimate destruction.

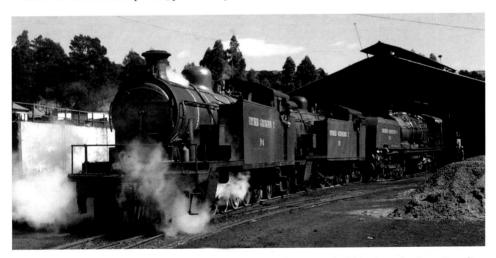

Industrial steam locomotives were once a common sight in South Africa's coal mines. Standing outside the locomotive shed are three Vryheid Coronation Colliery locomotives, all painted in bright blue. In the lead and in steam is VCC No. 4 (North British 26245, 1948), followed by VCC No. 1 (North British 27099, 1951). The third locomotive is VCC No. 5, a massive 4-8-2+2-8-4, which was one of fifty Beyer Garratts built in 1945–47 and originally delivered to the South African Railways as SAR Class GEA No. 4031 (BP 7168–7217).

Regarded as Africa's Orient Express, the Blue Train is the 'palace on wheels' of the South African Railways. As its name implies, this train is painted in royal blue and cream. It was withdrawn from service during the Second World War, and thoroughly refurbished and modernized in the seventies. A new Blue Train was introduced in 1997, and its traditional route between Cape Town and Pretoria was extended northwards as far as the Victoria Falls. In the following year a second identical train came into service, taking passengers to the western edge of the Kruger National Park, and to Port Elizabeth at the eastern end of South Africa's Garden Route.

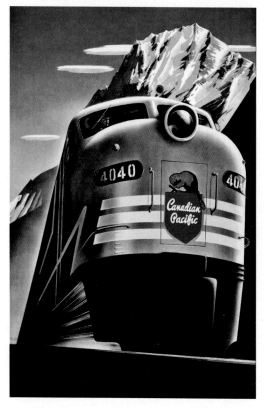

The Canadian Pacific Railway hardly requires an introduction. Incorporated in 1881, it currently owns around 20,000 km of track in Canada and into the United States, stretching from Montreal to Vancouver, and as far north as Edmonton. The CPR also serves Minneapolis, Milwaukee, Detroit, Chicago and New York City. A sense of power emanates from this 1950s poster, showing type FP diesel locomotive No. 4040 charging at full speed across the Canadian Rockies.

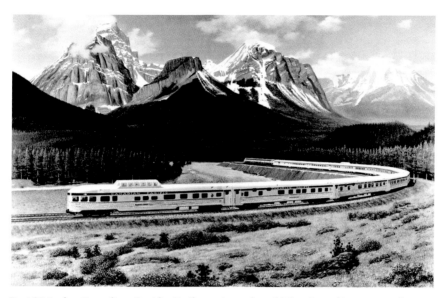

In 1955, the Canadian Pacific Railway introduced The Canadian, a new luxury transcontinental train. However, only a few years later the company decided to pull out of passenger services. Finally, in October 1978, CP Rail transferred its passenger operations to Via Rail, a new operator. This official CP photo shows The Canadian train in all its glory, with two dome cars and stainless steel coaches. Towering high over the train are the majestic Canadian Rockies.

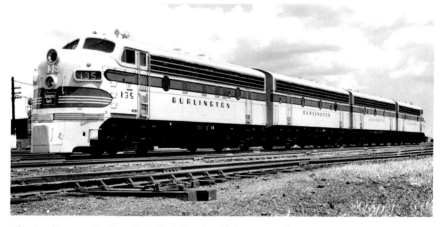

The Burlington Railroad (officially the Chicago, Burlington & Quincy) operated between Chicago and Denver, and to the south through its subsidiaries, Colorado & Southern and Fort Worth & Denver. It was famous for its Zephyrs, with the first one appearing in 1934. Through a series of mergers, it became first Burlington Northern and today goes by the name Burlington Northern Santa Fe. Burlington Railroad No. 135 was an FT type diesel locomotive. Each unit had 1,350 hp, and while Burlington used their FTs in freight service, Santa Fe used similar units to power their Super Chief and other named trains, making the FT a truly dual-purpose locomotive. While the FT made quite a dent in the rosters of steam locomotives, its successor, the F3, almost completely wiped out main line steam. Built between November 1939 and November 1945, there were 555 A-units with 541 'B' units. None of these were sold overseas.

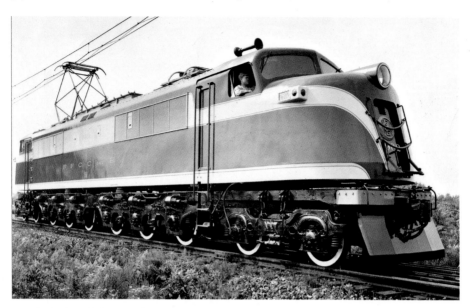

In 1949, the Chilean Railways took delivery of four colossal locomotives. They were described in detail as follows: 'This 230 ton rail giant, and another just like it, are the largest electric locomotives to be exported by the General Electric Company. Built by the company's Locomotive & Car Equipment Divisions at Erie, PA the first was shipped from New York earlier this month, and the second will leave Erie this week. The locomotives, built for wide gauge, are 76 feet long. They are rated at 4,000 horsepower each, have a maximum speed of 75 miles per hour, and were designed especially for freight and passenger operation on heavy grades. They will be used on the electrified division of the Chilean State Railways. With two more units built by Baldwin-Westinghouse, four of these 1,676 mm gauge locomotives will be delivered to Chile in 1949 as E-2901 to 2904.'

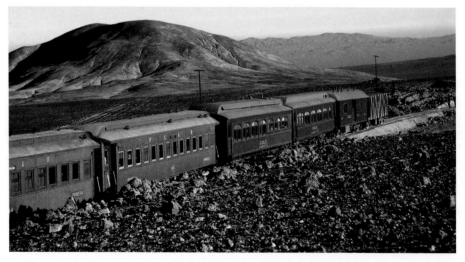

High in the Andes Mountains between Chile and Bolivia, a color photo dated to March 1977. This was the international train from Antofagasta to Salta, made of clerestory coaches belonging to the Ferrocarril Antofagasta-Bolivia (FCAB) in green and Ferrocarril del Estado (Chile) in blue.

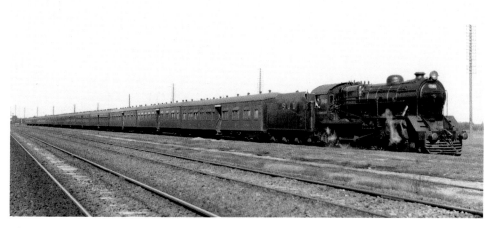

The Buenos Aires Great Southern Railway (BAGS) was one of the Big Four broad gauge (1,676 mm) British-owned companies that built and operated railway networks in Argentina. It was founded in 1862 and its first general manager was Edward Banfield, after whom the Buenos Aires suburban station of Banfield was named when it opened in 1873. When President Juan Perón nationalized the Argentine railway network in 1948, the company became part of the state-owned company Ferrocarril General Roca. BAGS Class 12K 4-6-2 steam locomotive No. 3940 *San Luis* was built by Vulcan Foundry in 1938 under the works number 4811. With fifteen coaches in tow, it is seen at Temperley station, in Buenos Aires, in itself named after the Newcastle textile merchant and businessman George Temperley.

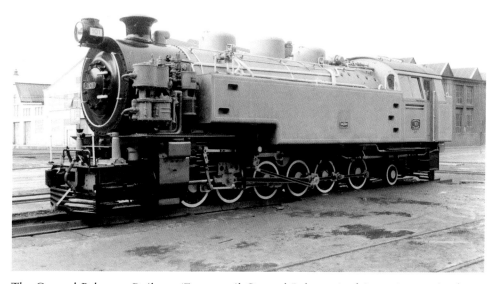

The General Belgrano Railway (Ferrocarril General Belgrano) of Argentina received two German-made 0-12-2T steam locomotives in 1955. These oil-fired Class E24 giants, numbered 100 and 101 (Esslingen 5135–36), were built for the 11.3 km long León (altitude 1,625 meters) to Volcán (2,078 meters) rack section on the Tucumán (Argentina) to Potosí (Bolivia) railway. They were modern and well-designed locomotives, but proved too complicated for the basic facilities of the line. Also, they remained out of service with cracked frames and cylinders, and were relegated to stationary boilers as soon as diesels arrived.

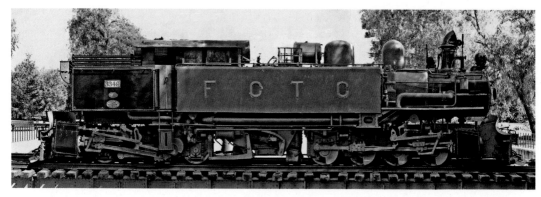

In South America, the Transandine Railway was once the connecting link between the Argentine and Chilean railway systems. Its purpose was to connect the east and west coast ports of Buenos Aires and Valparaiso. It operated from 1910 to 1984 between Los Andes in Chile and Mendoza in Argentina, where it met the Argentine Great Western Railway. To cross the Andean mountains, the railway had to climb up to Uspallata Pass, 3,810 meters (12,500 feet) above sea level. The colossal dimensions of the Kitson Meyer locomotive, seen in this photo, are hard to miss. Both the Ferrocarril Trasandino Chileno (FCTC) and the Ferrocarril Trasandino Argentino (FCTA) used Kitson Meyer locomotives. One of the surviving ex-FCTC units, EFE No. 3349 (Kitson 4664, 1909), was retired in 1978, long after the Transandine Railway had been electrified. Today it rests on a turntable at the railway museum in Quinta Normal Park, Santiago de Chile. Sister locomotive No. 3348 still exists and awaits restoration. (Photo by Nick Fisher)

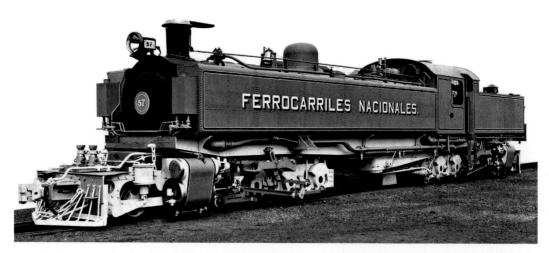

The Ferrocarril Girardot (later on, National Railways of Colombia) received two Meyer type locomotives in 1935 (Kitson 5471–5472). The order for this pair of 2-8-8-2Ts was placed with Kitson, which by then was no longer able to undertake the construction of new locomotives. The parts were therefore manufactured in Leeds, and the actual construction of the locomotives was transferred to Robert Stephenson & Hawthorn. These Kitson Meyer locomotives had in fact carried the RSH works numbers 4110 and 4111.

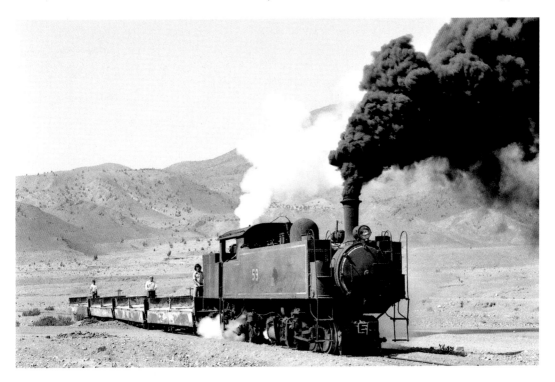

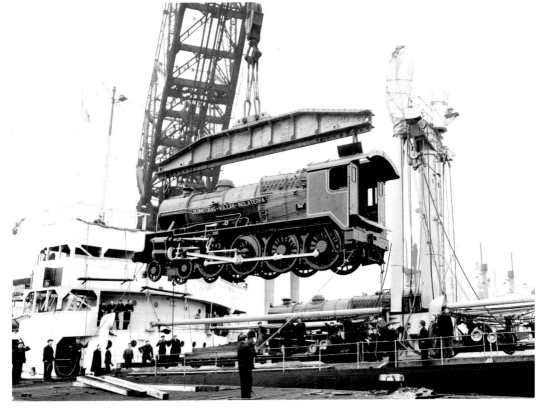

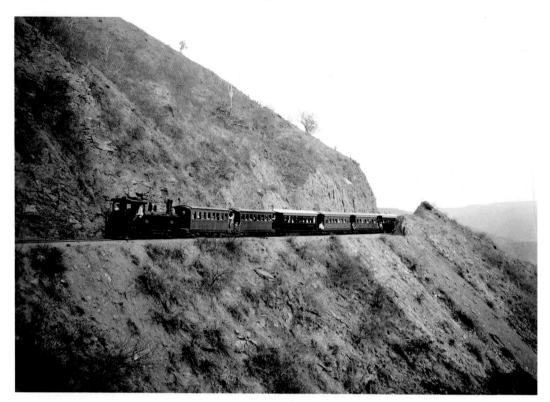

Above: Described as the world's most crooked railway, the Ferrocarril La Guaira y Caracas was Venezuela's own version of a mountain railway. As its name suggests, it connected the Venezuelan capital, Caracas, with the Caribbean port town of La Guaira. This relatively short railway was built when an English group secured a contract in 1881 and began construction of a 23-mile line up the hills overlooking the sea. The line began carrying passengers in July 1883 with eight 0-6-4T steam locomotives that were ordered in 1882 from Nasmyth Wilson, along with passenger and freight cars. Four 0-6-2Ts arrived from Beyer Peacock of Manchester in 1888, and a second batch of six Nasmyth Wilson 0-6-2Ts was added in 1890. In this photo, a passenger train is nearing the 3,000 feet level as it climbs the Andes from La Guaira to Caracas. The locomotive is a Beyer Peacock 0-6-2T.

Opposite above: The Anglo-Chilean Nitrate & Railway Company was founded in London in 1882. It relied on two narrow gauge lines, completed in 1890, for the transport of nitrate. The first was the Ferrocarril de Tocopilla a Toco (FCTT) and the second and longer line was the Ferrocarril Salitrero de Taltal (FCT). Fifteen of the FCTT locomotives were of the Kitson Meyer type, while another thirteen worked on the Taltal Railway. They proved to be capable locomotives, hauling 125-ton trains up the demanding gradients of the lines. Ferrocarril Salitrero de Taltal 0-6-6-0T Kitson Meyer locomotive No. 59 displays the distinctive dual exhaust system of this type (smoke at the front and spent steam at the back from the rear cylinders) in March 1977. It was built by Kitson under the works number 4656 in 1909.

Opposite below: Shortly before the nationalization of the Argentine railways, an order was placed with Vulcan Foundry for thirty 4-8-0 mixed traffic steam locomotives for the Buenos Aires and Great Southern Railway (VF 5628–5657, 1948). These were delivered to Argentina in 1949 as a development of an earlier version of locomotives already supplied to the same railway company. Two of the new Class 15B locomotives are being loaded at Birkenhead Docks, Liverpool, in 1948. Note the partly exposed boilers. It is unclear why the boiler cladding was left off until arrival at the destination country.

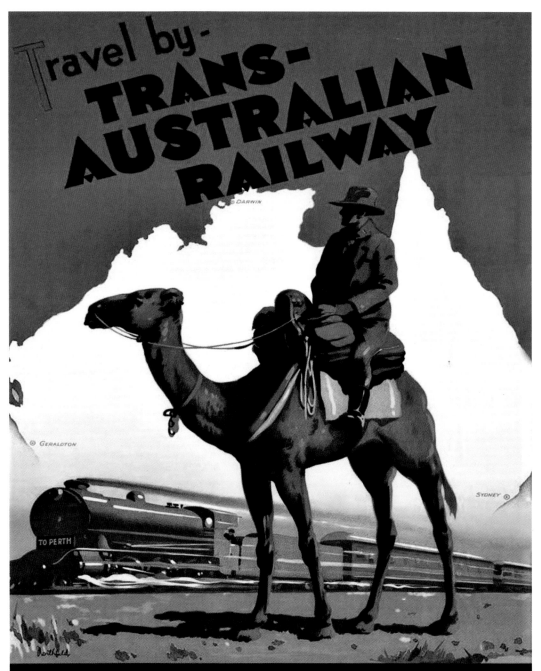

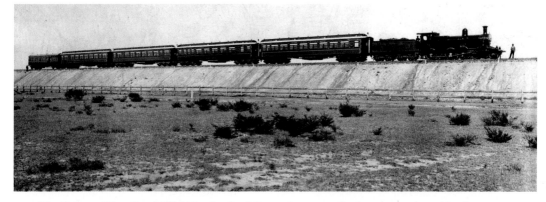

The Sydney (New South Wales) suburb of Campsie was perfectly empty when this photo was made, more than a century ago. New South Wales Government Railways Class C32 steam locomotive No. P513 hauls a passenger train made of second and first class coaches, two American-built Pullman Vestibule sleeping cars and, finally, a guard van. The first C32s arrived from Beyer Peacock of Manchester in 1892. Further orders over the next nineteen years resulted in a total of 191 locomotives that were built by Baldwin of Philadelphia and locally in Australia by Clyde & Eveleigh.

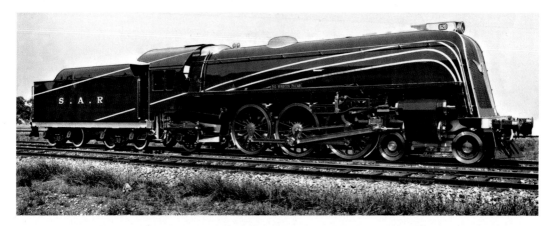

Above: Looking dazzling and amazing, South Australian Railways No. 620 *Sir Winston Dugan* was decorated in green and silver for the Centenary Train, which toured the state during the centenary of South Australia in 1936. This South Australian Railways (broad gauge) 4-6-2 emerged from Islington Railway Workshops in 1936 to become Australia's first streamlined locomotive. Its smokebox was covered with a chromed steel grille, and it was painted in Hawthorn green with yellow stripes. Two other locomotives, No. 621 and 624, have survived, the first operational and the second on static display.

Opposite: The Trans Australian (originally known as the Trans Australian Express) was a passenger train that began running between Port Augusta and Kalgoorlie in 1917. It was later extended west to Perth and east to Port Pirie and Adelaide following the conversion of the line to standard gauge. One of Australia's longest running trains, the Trans Australian was finally withdrawn in June 1991.

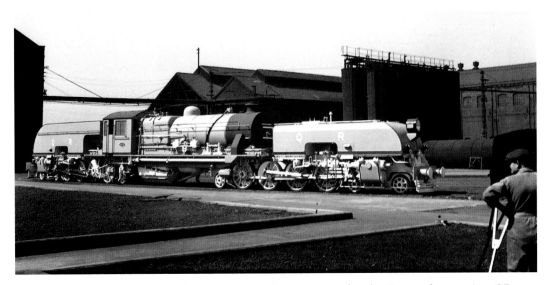

Australia's Queensland Railways were another customer for the Garratt locomotive. QR No. 1002 was a Beyer Garratt type 4-8-2+2-8-4, built by Beyer Peacock in 1950 (BP 7342). It was officially recorded on camera at the manufacturer's own Gorton Foundry in Manchester, prior to delivery to Australia. Having completed the first ten locomotives, and owing to a full order book, Beyer Peacock subcontracted the construction of the remaining twenty locomotives to Société Franco Belge de Materiel du Chemins de fer in Raismes, France. The last of the Queensland Garratts were retired by 1969. One locomotive, No. 1009, was saved and placed on display in the Redbank Locomotive Museum. It was fully restored at Ipswich Railway Workshops and can be admired today in the steam shop there.

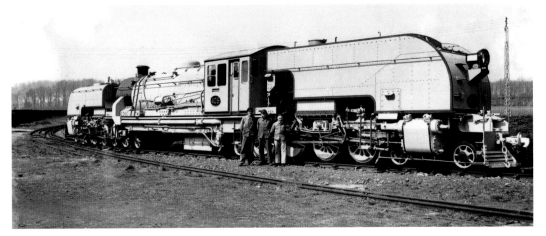

The South Australian Railways 400 Class was made of ten 4-8-2+2-8-4 steam locomotives built in the early 1950s. These locomotives hauled mineral trains on the narrow gauge Broken Hill line from 1953 to 1963, operating as far south as Port Pirie and as far north as Quorn. Retired when replaced by diesel locomotives, in 1969 they were temporarily returned to service while their diesel successors were being converted to standard gauge. SAR Garratt No. 405 was ordered from Beyer Peacock in 1953, and subcontracted to Franco Belge (BP 7622–31/FB 2973–82). Happily, two are preserved. No. 402 is at the Zig Zag Railway, Lithgow (NSW), and No. 409 is at the National Railway Museum, Port Adelaide.

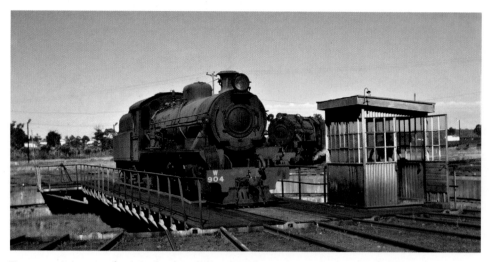

From a private set of original color slides, this photo shows Western Australian Government Railways Class W 4-8-2 steam locomotive No. 904 on the turntable in Collie, Western Australia. A second steam locomotive is seen behind the turntable. Collie roundhouse still exists, along with the turntable, however both have long since been abandoned. No. 904 was built by Beyer Peacock in 1951 (BP 7381). It entered service on 21 May of the same year and withdrawn on 17 June 1971. Of the sixty members of this class, fifteen are known to have escaped the cutter's torch and are on static display in various museums in Australia.

The South Australian Railway ordered a 2-2-0WT steam railcar from Kitson of Leeds in 1905. More than a century later, this is a recent view of the same railcar. It is now in the care of the Pichi Richi Railway Preservation Society, and goes by the amusing name of The Coffee Pot. Seating is provided for nine first and thirteen second class passengers in separate compartments. Previously referred to as Steam Motor Coach 1 when it was still under South Australian Railways ownership, this train was used on a weekly parcels and mail trip to Hawker, in the Flinders Ranges area of South Australia. It was also available for charter, and was regularly used to carry tennis and football clubs. The Coffee Pot returned to service in 1984 following an extensive restoration project. It is the only example of its type still operating in the world. (Photo by Caleb's Rail Films)

Sixty years ago in Australia. Midland Railway of Western Australia steam locomotive No. C 18 (Kitson 4885, 1912) on a rail tour on 9 October 1960. The MRWA had effectively dieselized in 1958, but retained C 18 on standby. It was used on a couple of rail tours in 1960 and 1962. Retired in April 1963, it was cut up in July 1963. (Photo T04947 by Rail Heritage WA)

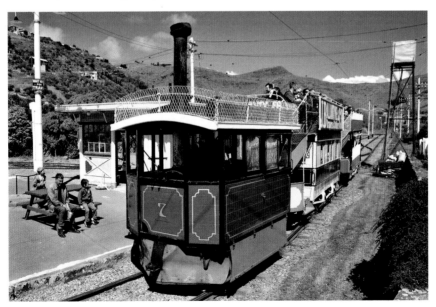

A steam tram in New Zealand. Beautifully restored and in full running condition, No. 7 (Kitson 2402, 1881) was one of eight units delivered to the Canterbury Tramway Company. It was acquired in the 1960s from the Christchurch Transport Board and thoroughly restored. It first went into service on the opening of the Ferrymead Tramway in January 1968. It is believed to be one of only three Kitson steam trams that remain in existence, and the only one still in operating order. (Photo by Bernard Spragg)

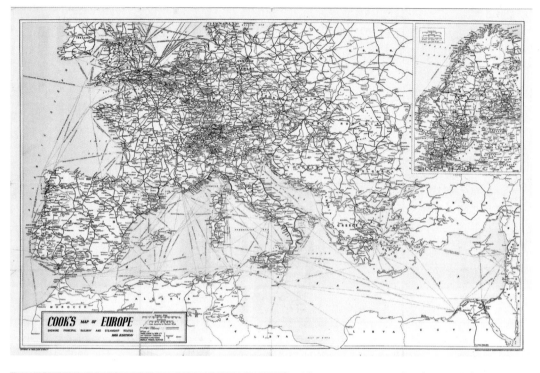

Above: Europe, North Africa and the Middle East railway map (1955).

Left: It seems hard to believe at first and yet, this seemingly contemporary photo was in fact taken more than ninety years ago. Perched high over the ground and with no visible safety cable to prevent a painful drop, a railway signal technician is seen at work in Germany, in September 1929.

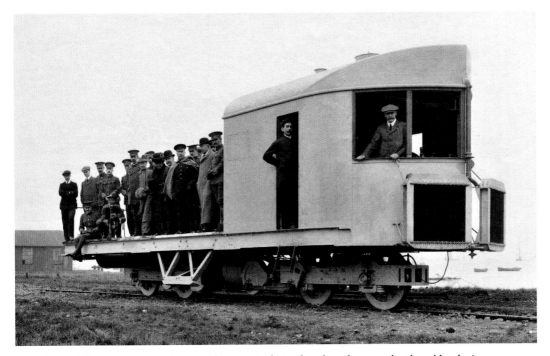

Above: The Brennan Gyro Monorail was a single track railcar that was developed by the inventor Louis Brennan (1852–1932). It weighed 22 tons, and was designed to carry up to 10 tons. The railcar was balanced by two vertical gyroscopes mounted side by side, and spinning in opposite directions at 3,000 rpm. In 1903, Brennan patented a gyroscopically-balanced monorail system originally designed for military use. The system was demonstrated on 10 November 1909 at Gillingham, England. At the 1910 Japan-British Exhibition in London, Brennan built a mile long monorail track and invited forty passengers at a time to ride his train. Winston Churchill (then Home Secretary) was one of the passengers and then drove the railcar personally. Brennan was awarded the Grand Prize, but despite the system's proven ability to remain perfectly balanced even when stationary, it never became commercially successful. Other than the possibility of a potentially disastrous gyroscope failure, it was discovered that any wagons towed by the locomotive would also need the same powered gyroscopes, thus making the whole project impractical.

Overleaf above: Members of the British Cabinet inspecting the Brennan gyro monorail. The gentleman in the top hat, second to the right of the white lamp, is Winston Churchill. Sitting on the handrail is David Lloyd George.

Overleaf middle: American steam locomotives were exotic in Europe. In 1915, the Serbian State Railways took delivery of ten 760 mm gauge American Locomotive Company (Alco 55117–126) 2-6-6-2 Mallett locomotives. Numbered 551 to 560, they were captured during the Austrian-German occupation of Serbia in the First World War. All ten locomotives were confiscated by the Austrian and German military authorities, each party receiving five locomotives. After the end of the war in Europe, nine of the locomotives became JDZ Class 93. One locomotive was destroyed in the war.

Overleaf below: The only known photo of the single American-built Mallett steam locomotive, which was destroyed in Serbia during the First World War. The locomotive appears to have sustained considerable damage, perhaps due to a landmine explosion. Derailed wagons are scattered on both sides of the track, giving an idea of the brutal attack on the train.

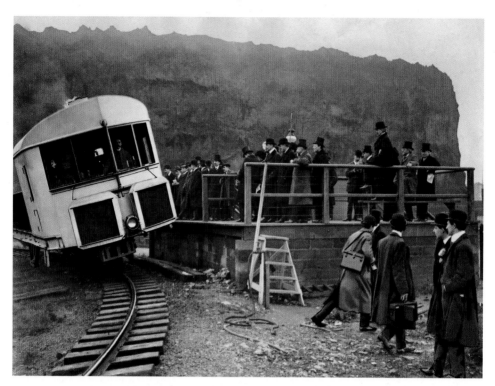

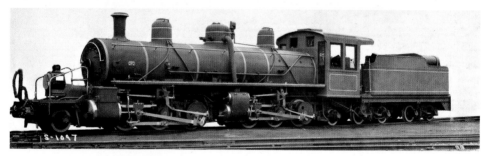

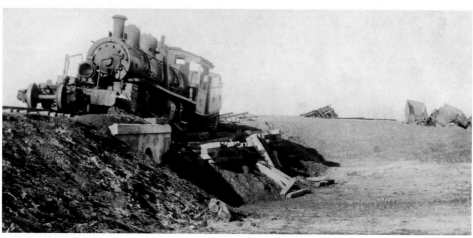

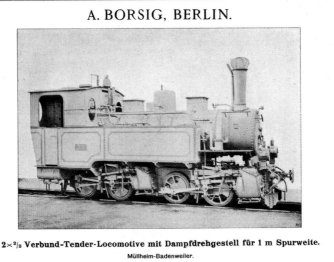

A. BORSIG, BERLIN.

2×²/₂ Verbund-Tender-Locomotive mit Dampfdrehgestell für 1 m Spurweite.

Müllheim-Badenweiler.

Cylinder-Durchmesser . ²³⁰/₃₇₅ mm	Räderdurchmesser 800 mm	Kesseldruck . 12 Atm.	Heizfläche . . 42,79 qm
Kolbenhub 380 mm			Rostfläche . . 0,87 qm

Gewicht leer 20,0 t

„ betriebsfähig 25,5 t

Gebaut 1898.

39

Local railways had once served a good many communities across Europe, in the long lost days before the advent of the private car. In the south-western German province of Baden, halfway between Freiburg and Basel, the meter gauge Localbahn Müllheim-Badenweiler was established in 1896 to connect the two small towns over a short distance of only 7.57 km. Three Borsig steam locomotives, a few coaches, a postal van and a pair of wagons were the railway's entire fleet. This Borsig Mallett, built in Berlin in 1898 as works number 4644, was the railway's third locomotive. The line was electrified in 1914 and closed down in 1955.

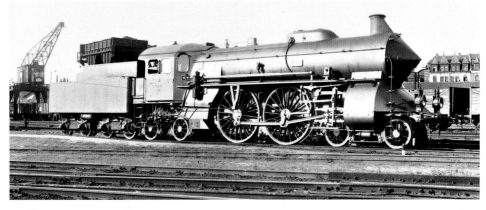

The S 2/6 is an elegant example of German high-speed steam locomotives from the period before the First World War. Built by Maffei of Munich in 1906, it originally belonged to the Royal Bavarian State Railways (Königlich Bayerischen Staats-Eisenbahnen) as their No. 3201. It is here seen in Nürnberg in 1925, prior to entering the railway museum. Deutsche Reichsbahn (German State Railways) renumbered it as No. 15001. On 2 July 1907, running between Munich and Augsburg with a train of four coaches, this locomotive attained a record speed of 154.5 km/h.

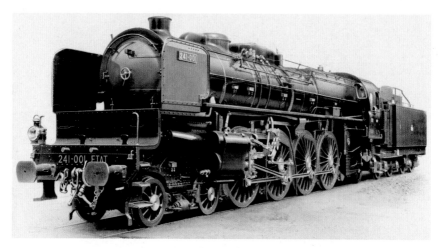

The Eastern Railway of France (Est) operated forty-one of these large 4-8-2s, out of a total of ninety locomotives built between 1926 and 1933 by Fives Lille and SACM Grafenstaden. Forty-nine more belonged to the French national railway company. In 1938, they were renumbered as 241-A-1 to 90, and placed in service on the formerly Eastern Railway Company's territory. This locomotive carried the number 241 001, then 241 301, and finally 241-A-65. The class was retired between 1960 and 1970. One locomotive, 241-A-1, is at the French National Railway Museum. Another, No. A-65, is operated by a Swiss society named Verein 241-A-65.

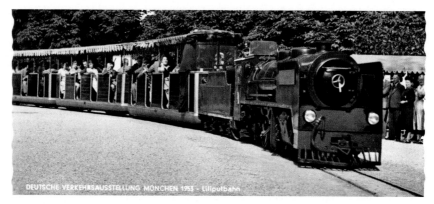

Held in Munich between 20 June and 11 October 1953, the German Transport Fair (Deutsche Verkehrsausstellung München, or DVA) was a huge draw for visitors from near and far. Exhibiting a wide range of anything from mainline locomotives and passenger trains to track maintenance machinery, a Liliputbahn (garden railway) was used to carry the guests around the fairground. In charge of the little Bavaria Express was a live steam locomotive built by Krupp of Essen. It was one of three 4-6-2s built in 1937 (K 1662–64) and, having been named *Blitz*, *Donner* and *Doria*, supplied to the Rheinbahn in Düsseldorf for a Third Reich public show, which was held there in October of the same year. Fortunately surviving the war, all three locomotives were renamed *Rosenkavalier*, *Männertreu* and *Fleissiges Lieschen* and put back in service. After several years in storage, *Rosenkavalier* and *Männertreu* were sold to Alan Bloom, the British horticulturist and steam enthusiast, for his private museum in Bressingham Hall. *Fleissiges Lieschen* found a new home in 1976 with the Romney, Hythe & Dymchurch Railway. The locomotive now carries the RHDR number 11 and goes by the name *Black Prince*.

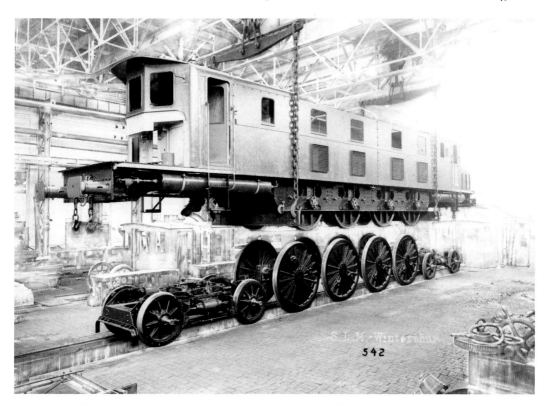

Above: The Swiss Locomotive & Machine Company, or SLM as it was better known, was a major manufacturer of steam, diesel and electric locomotives in the city of Winterthur. This photo shows a prototype locomotive, which was either sold to, or especially built for, a French client. French locomotive builders have often cooperated with SLM in the design and construction of new and experimental electric locomotives.

Overleaf above: The 1930s were the golden age of the railways in Germany, and a decade of marked technological improvements. The introduction of faster, stronger and more reliable steam locomotives led to an open rivalry with the equally promising market for new diesel trains. Thus was born the Henschel Wegmann Train, on the initiative of the German locomotive industry. The HWT was a streamlined express train whose elegant, Wegmann-built coaches were coupled to one of two Henschel-built Class 61 steam locomotives. The train ran regularly between Berlin and Dresden from June 1936 to August 1939, specifically to demonstrate that a modern steam locomotive could successfully compete with the Reichsbahn's new high-speed diesel trains. The locomotive reached a top speed of 175 km/h thanks to its large driving wheels, which had a generous diameter of 2,300 mm. In scheduled service, a slightly lower speed of 160 km/h was enough to cover the distance of 176 km between the two cities in an impressive 102 minutes. Of the two Henschel locomotives, No. 61 001 was a 4-6-4T delivered in 1935 and its twin, No. 61 002 (4-6-6T), arrived in 1939.

Dresden-bound DR No. 61 001 is seen pulling out of Berlin's legendary Anhalter railway terminal with the Henschel Wegmann Train, with passengers waving from the windows and blissfully unaware of the impending catastrophe that was yet to descend upon Germany in the Second World War. Anhalter station survived the air raids on Berlin, but was tragically demolished after the war. No. 61 001 ended up in the British Zone after the war, and returned to service until damaged in an accident and sadly scrapped in 1957. No. 61 002 remained in Dresden and was rebuilt in East Germany in 1961. It now carries the road number 18 201 and is in private ownership.

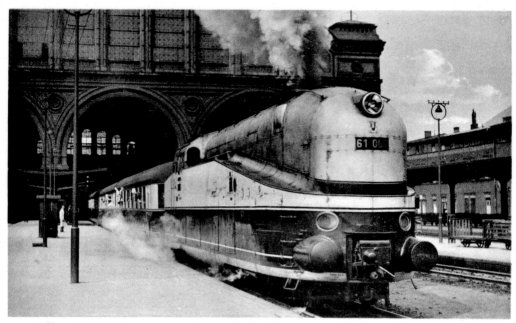

Henschel-Wegmann-Dampfschnellzug mit Mitropa-Bewirtschaftung

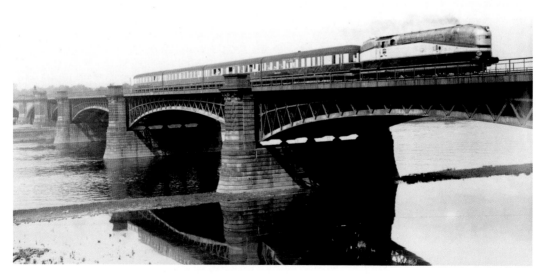

Minutes after departure from Dresden Neustadt station, DR No. 61 001 is seen crossing the Elbe River with the D53 express train on 2 June 1936. The train left Dresden at 09:31 in the morning and would be expected in Berlin at 11:12.

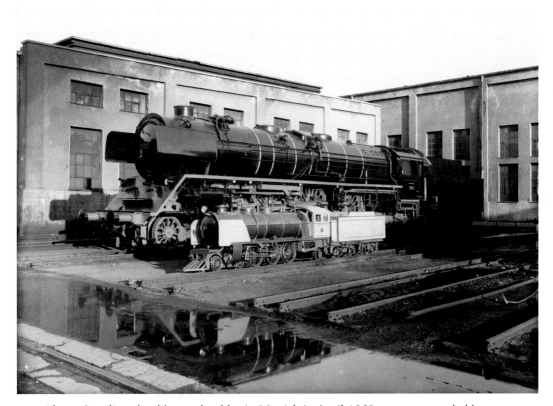

Above: Standing shoulder to shoulder in Munich in April 1950 are two remarkable steam locomotives. To the left, Deutsche Bundesbahn (German Federal Railways) No. 05 002 (Borsig Locomotive Works, Berlin, 14553, 1934). To the right, a 4-6-2 built by Krauss under the works number 17655. No. 05 002 was sent to Munich for a complete overhaul, including the removal of its beautiful streamlined casing. It was then assigned to haul express trains between Hannover and Cologne. Of the smaller Pacific, it was built to the gauge of 381 mm, and delivered to TELCO in India in 1951. It ended up with a children's railway in New Delhi. This fine little locomotive still exists today in India, intact but desperately in need of salvation.

Overleaf above: Deutsche Reichsbahn (German State Railways) Class 05 steam locomotive No. 05 001 was the first of three streamlined 4-6-4s built by Borsig of Berlin in 1935. Designed and built to haul express trains, it remained in service after 1945 until finally retired in July 1958. Today it may be admired at the Verkehrsmuseum in Nürnberg.

Overleaf below: The French state-owned sales consortium Groupement de´Exportation de Locomotives en Sud Amérique (GELSA) delivered ninety French-built (Cail, Schneider, Batignolles Châtillon and Fives Lille) 2-8-4 and 4-8-4 steam locomotives to Brazil's meter gauge railways in 1951 and 1952. Designed by André Chapelon, the large and powerful 2-8-4s could run on light rails of 22 kg per meter with a maximum axle load of 10 tons. Three tender types, ranging from light to heavy, were available. Although modern and of the highest quality, the GELSA locomotives were viewed with suspicion immediately upon arrival in Brazil. This was attributed to the presence of old and worn out steam locomotives in that country. More to the point, in the 1950s the age of steam was quickly coming to an end in Brazil. With the transition to diesel power in full swing, the GELSA locomotives were all retired after only a few years in service. The few ones that were present in the south of Brazil were leased to the Bolivian Railways. All were scrapped.

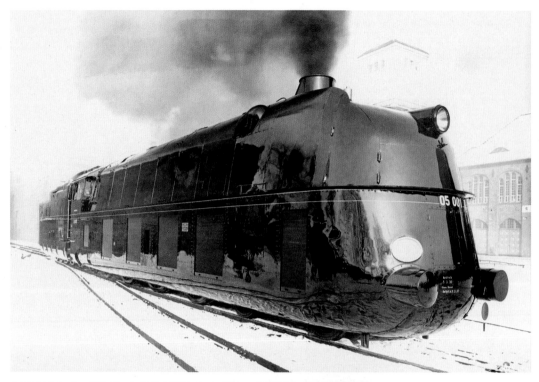

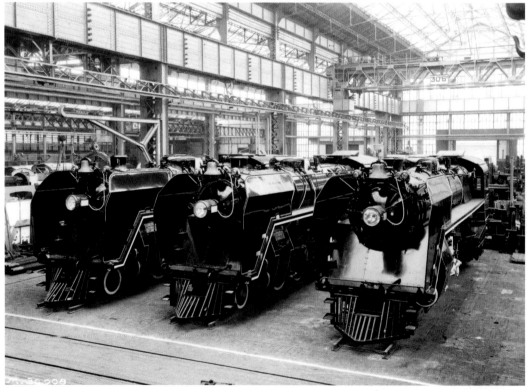

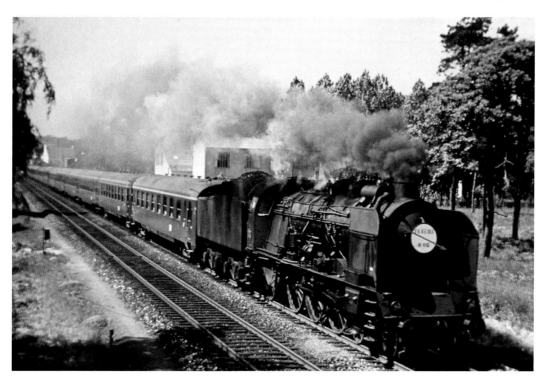

Above: 'The Fléche d'Or standing on the quay at Calais is a symphony of brown, cream and blue Pullmans in front, and sleeping cars at the rear. One or two of these cars form a part of the celebrated "Blue Train", and on arrival in Paris are worked round from the Gare du Nord to the Gare de Lyon, there to be attached to the Blue Train proper – an express made up entirely of first class sleeping cars carrying holidaymakers to the Riviera. Another sleeper is labeled "Rome" and is attached at the Gare de Lyon to the equally famous Rome Express – a train of first and second class sleeping cars which passes through the Mont Cenis Tunnel on the way to Turin, Genoa, Pisa, and Rome.' (*Railway Wonders*, 22 March 1935).

The Flèche d'Or (The Golden Arrow) was a luxury French boat train of the Chemin de Fer du Nord and later SNCF. It linked Paris with Calais, where passengers took the ferry to Dover for the next part of the voyage to London aboard the Golden Arrow of the Southern Railway, and later on, British Railways. In a recent color photo, a French Pacific locomotive is seen with a special train commemorating the original Fléche d'Or.

Overleaf above: In the first few years after 1945, much of the French national railway system lay in ruins following the damage caused in the Second World War. Wishing to rebuild its fleet of locomotives, the French National Railway Company (SNCF) turned to several locomotive manufacturers in America and Canada under the Lend-Lease Program. This photo shows one of the many new 2-8-2s ordered by France, in this case SNCF 141R 1029 (Lima Locomotive Works, Ohio, 9120, 1946). Of the 1,340 locomotives that were eventually constructed, seventeen (141R 1220–1235 and 141R 1241) were lost at sea when the ship transporting them, the *Belpamela*, sank in a violent storm off Newfoundland on 11 April 1947. Twelve locomotives are preserved, several in operating condition. Locomotives 141R 420, 840, 1126 and 1199 have been officially declared monument historique in France.

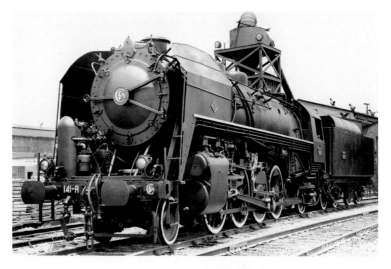

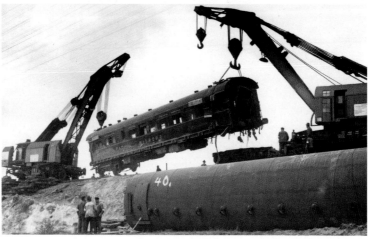

The case of Szilveszter Matuska (29 January 1892 – disappeared in 1945) is one of the strangest ever told, even more so since it is directly associated with railway history. Matuska, an Austro-Hungarian mechanical engineer, repeatedly attempted to derail passenger trains in Hungary, Germany and Austria in 1930 and 1931. His first successful attack was the derailment of the Berlin–Basel express train on 8 August 1931, injuring over a hundred passengers. One month later, at twenty minutes past midnight, on 13 September 1931, Matuska successfully dynamited the Vienna Express as it was crossing a bridge near Budapest, sending the locomotive and nine of the coaches down a deep ravine. Twenty-two passengers were killed in the attack, and another 120 were wounded. He was discovered at the scene of the crime but, pretending to be a surviving passenger, was released. Following an international investigation, Matuska was discovered and arrested in Vienna on 10 October 1931. He was tried, found guilty and sentenced to death. His sentence was commuted to life imprisonment. Last seen in 1945, when he escaped from jail, Matuska's fate remains a mystery to this day.

Matuska's terror attack on the Berlin–Basel (D34) express train occurred outside Jüterbog, south of Berlin, on 8 August 1931. This photo clearly demonstrates the aftermath of his assault. A derailed Mitropa dining car is being lifted up by two cranes. An overturned coach is lined up along the railway line.

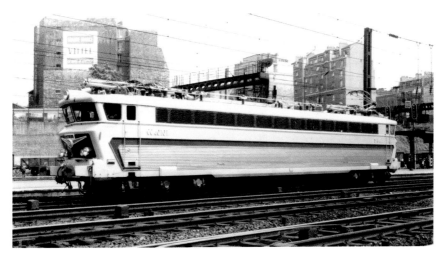

One of the most beautiful locomotives ever built, and an icon of industrial design, the French CC 40100 was the first of the 'Nez Cassés' ('broken nose') locomotives designed by Paul Arzens. The ten Alsthom locomotives in this class were delivered between 1964 and 1970, and were all allocated to the prestigious Trans Europe Express (TEE) routes between Paris, Brussels and Amsterdam. Mechanically, the class combined three innovations in locomotive design: quad-voltage working, three-axle monomotor bogies and the then-new Nez Cassés body style. The sides of the locomotives were decorated with ribbed stainless steel panels. Six near-identical locomotives were also built for Belgium in 1973/4. The last CC 40100 services were in the summer of 1996. A commemorative TEE train trip was organized in June 1996, hauled by CC 40109 and 40110. SNCF CC 40101 is exhibited at the Cité du train in Mulhouse.

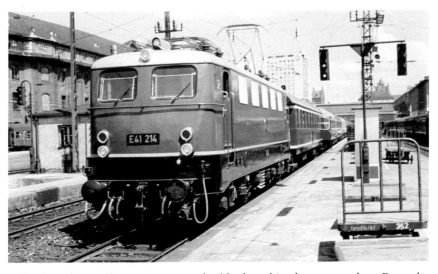

In bright colors and not even a month old when this photo was taken, Deutsche Bundesbahn (German Federal Railways) electric locomotive No. E41 214 stands in Munich Central station in June 1962 with a train of first class coaches. Right behind the locomotive, in red, the leading coach is a conference car, presumably used in connection with the 1962 International Railway Conference. No. E41 214 was delivered new to DB on 5 June and was stationed in Frankfurt.

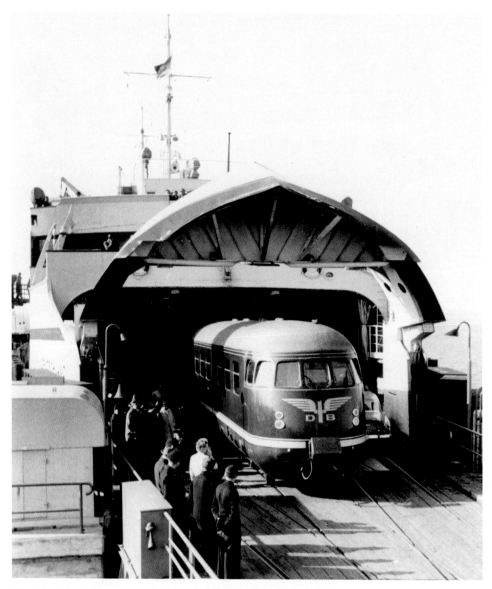

The Vogelfluglinie (German) or Fugleflugtslinjen (Danish) is a main transport corridor connecting Copenhagen with Hamburg. In 1951, a regular ferryboat service was established between Großenbrode, in Germany, and Gedser, in Denmark, to transport passenger trains between the two countries. The inauguration of the Fehmarnsund Bridge, in 1963, enabled a faster link on this route and on 14 May of that year, the Großenbrode–Gedser ferryboat service came to an end. Emerging from the ferryboat *Deutschland* in Großenbrode is a DB (German Federal Railways) Class VT 08 diesel train with the Copenhagen Express.

The VT 08 diesel sets were introduced in 1952 as West Germany's new high speed trains. Originally a three-car set, a fourth car was later added to accommodate additional passengers. In June 1957, a year before this photo was taken, these elegant sets were assigned to the new Trans Europe Express services to Paris and Amsterdam. They were lovingly called in Germany 'Eierkopf' ('eggheads') due to their ovoid cabs. Retired in 1985, some of the sets were sold off to private owners outside Germany.

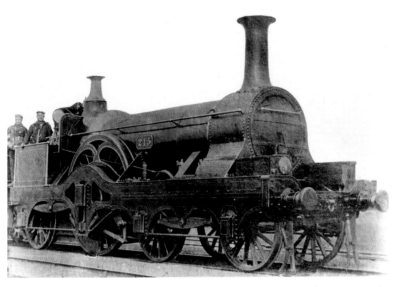

Archibald Sturrock (30 September 1816–1 January 1909) was born into a family of locomotive engineers. His uncle was Robert Stirling, the inventor of the Stirling Engine, and his cousins were James and Patrick Stirling. He began his lifelong career with the railways at the Dundee Locomotive Works, where he met Daniel Gooch, who recruited him to the Great Western Railway in 1841. In 1846, he became the first Works Manager at Swindon and four years later, the Locomotive Superintendent of the Great Northern Railway. While there, he was in charge of building several outstanding locomotives. His greatest achievement was locomotive No. 215, a 4-2-2 built to prove that it would be possible to run trains between London King's Cross and Edinburgh in eight hours. Sturrock later became a founding member of the Yorkshire Engine Company in Sheffield. He retired from the GNR in 1866 and passed away in London in 1909. GNR No. 215 was built by the Hawthorne Locomotive Works, Newcastle upon Tyne, in 1853. Its 7-foot 6-inch (2.29-meter) driving wheels were later reused on Patrick Stirling's No. 92, a 2-2-2 locomotive built at Doncaster Works in 1870.

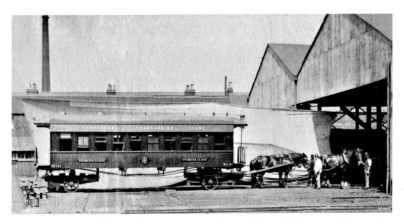

Moving loads around the works was once made possible with the use of heavy horses. A wooden first-class coach for Argentina's Ferrocarril Transandino rests on a pair of temporary wheels, as it is being towed around the Gloucester Railway & Carriage Works workshops in May 1892.

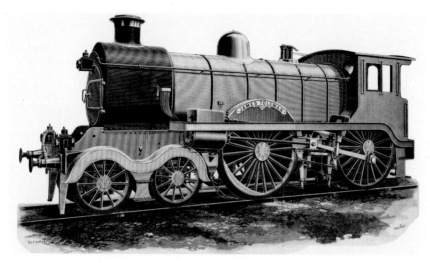

The *James Toleman* was an oddity locomotive. It was a simple, non-compound locomotive with four cylinders. The two cylinders outside the frames drove the rear driving wheels while the two cylinders under the smokebox and inside the frames drove the front driving wheels. There was no mechanical connection between the two. The 4-2-2-0 locomotive had an unusual boiler composed of two joined, near-circular sections. It was designed and financed by a certain Frederick Charles Winby of London, and built by Hawthorn, Leslie & Co. of Newcastle, England. *James Toleman* was exhibited at the 1893 Chicago World Fair, but proved unsatisfactory in tests due to low steaming power. Mr. Winby retained ownership throughout until he became disenchanted with the project and abandoned it. This unusual locomotive was professionally illustrated by John Swain for *The Engineer* magazine in April 1893.

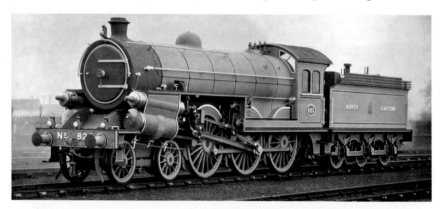

The North Eastern Railway Class S2 (later LNER Class B15) was the first 4-6-0 locomotive designed for mixed traffic. The last B15, No. 825, was built at Darlington Works in 1913 and fitted with Stumpf Uniflow cylinders. The Uniflow arrangement was intended to avoid condensation in the cylinders by having separate intake and exhaust ports on the cylinders. Steam flow was in one direction, hence 'Uniflow'. In theory it was a practical solution, but the system had one major setback. The exhaust ports were always of the same size, but the intake ports could vary in size according to the cutoff position. The system was fitted also to another locomotive, an LNER Class C7 4-4-2. Further experiments showed that the improvement was moderate and that special care was required in both cases. No. 825 was rebuilt with conventional cylinders and withdrawn from service in February 1944.

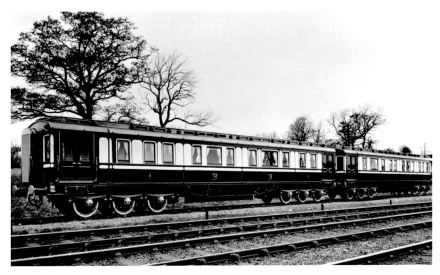

London & North Western Railway Royal Saloon coaches 800 and 801 (with Royal Crests but unnumbered during LNWR days) were built at the railway's Wolverton works in 1902/3 for King Edward VII and Queen Alexandra of Great Britain. When the LNWR was taken over by the London, Midland & Scottish Railway, the Royal Train coaches retained their LNWR livery and numbering but were repainted with LMS lettering. They remained in service until 1947, and are now in the National Railway Museum in York.

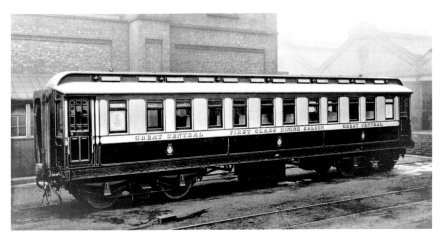

The Great Central Railway was created when the Manchester, Sheffield & Lincolnshire Railway changed its name in 1897, two years before the opening of the so-called London Extension. It was absorbed in January 1923 into the London & North Eastern Railway. The Extension commenced in Annesley, to the north of Nottingham, proceeding to Nottingham Victoria, Leicester, Rugby and finally to London Marylebone. In this Great Central publicity photo dated to 1899, GCR First Class Dining Saloon No. 1598 is presented at the railway's Gorton Works, in Manchester. Evidently a clerestory coach, with the usual raised roof to house oil lamps, a battery box for electric lighting is suspended under the center of the coach. Other notable features are the Gould couplers (an early variant of the later Buckeye couplers), the Pullman gangway, the transverse bogie springs, and the peculiar axlebox covers. The wheels appear to be of the Mansell patent type, consisting of wooden blocks forming a disc, and surrounded by a steel tyre held by a ring of rivets.

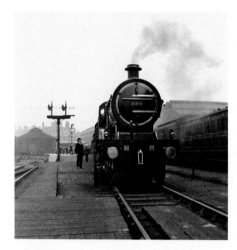

The Midland Railway (1844–1922, then merged with the London, Midland & Scottish Railway) was famous for its three-cylinder 4-4-0 compound locomotives, of which No. 1000 is preserved at York. The ten members of the 990 class were the simpler version, with two inside cylinders, for comparative purposes. Seen in a glass slide, MR No. 990 (Derby Works, 1907) is standing at Leeds Wellington Street, the Midland Railway terminus in Leeds. Built in 1850, the station was rebuilt yet again in 1938 to form Leeds City, combining the LNWR/NER joint New Station of 1869.

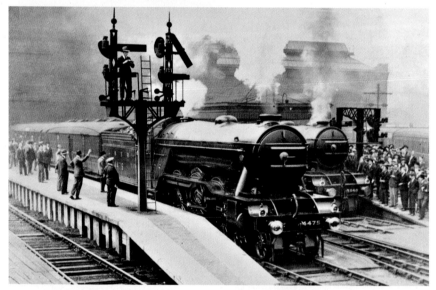

'OUT FOR RECORD – railway officials cheering the Flying Fox as it left King's Cross station for Scotland with a first stop at Newcastle, 268 miles away. The trip is hailed by the English as a new chapter in the history of British travel and the creation of a nonstop railway record.' The London & North Eastern Railway LNER A1 and A3 locomotives represented two distinct stages in the history of the British 4-6-2 steam locomotives. They were designed by Nigel Gresley for main line passenger services, initially on the Great Northern Railway (GNR), which was a constituent company of the London & North Eastern Railway. The change in class designation to A3 reflected the fitting to the same chassis of a higher pressure boiler with a greater superheating surface and a small reduction in cylinder diameter, leading to an increase in locomotive weight. Eventually all of the A1 locomotives were rebuilt, most to A3 specifications. LNER Class A1 (rebuilt to A3 in 1947) No. 4475 *Flying Fox* was built at Doncaster Works in 1923 under the works number 1567. It is here seen departing London King's Cross station on 23 July 1927 with sister engine No. 2548 *Galtee More* (Doncaster Works 1604, 1924) visible to the right. No. 4475 became British Railways No. 60106 in December 1948 and was scrapped in February 1965. Another A3, LNER No. 4472/BR No. 60103 *Flying Scotsman* is kept in running condition.

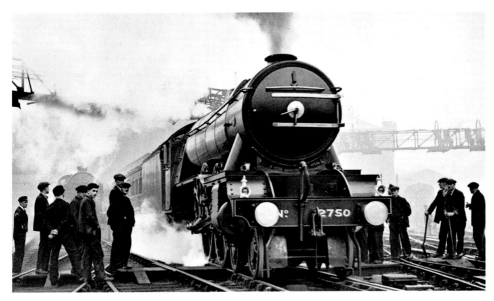

'London to Newcastle in 237 minutes – the LNER smashed another of its long distance records when a special train made the journey in three hours 57 minutes, a record for the London to Newcastle run over 268 miles. The fastest train hitherto running took five hours six minutes. The train was drawn by Papyrus, a Pacific type locomotive which has been used for some time on the Flying Scotsman service. For more than twelve miles between Grantham and Peterborough it travelled at 100.6 mph, so far the fastest speed obtained by any steam train for that distance. The record breaking train is seen leaving King's Cross station for Newcastle.'

LNER No. 2750 *Papyrus* (Doncaster Works 1708, 1929) became BR No. 60096 in October 1948. It was photographed in London on 5 March 1935.

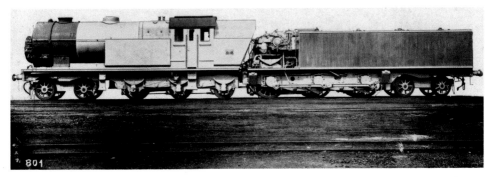

The Ljungström 4-2-2-2-6-4 steam turbine locomotive (Beyer Peacock Locomotive Works, Manchester, 6233, 1926) was a single experimental unit constructed in Britain under license and to the design of the original inventor, the Swedish engineer Fredrik Ljungström. Following preliminary trials, it was lent to the London, Midland & Scottish Railway, to be tested between London, Manchester and Glasgow on express trains. The locomotive consisted of two parts, one part carrying the boiler and the other supporting the turbine and the condenser. The turbine was designed to develop 2,000 hp at 10,000 rpm and drove the leading pair of wheels. Two other axles were coupled to the driving axle. The air-cooled condenser consisted of 2,500 copper tube elements, arranged vertically on each side. Air was drawn between these tubes by four turbine-driven fans. A pump, driven from the fan shaft, circulated boiler feed water through the auxiliary condenser. The locomotive's performance was disappointing, however, due to poor heating of the boiler, and in the end the project was abandoned.

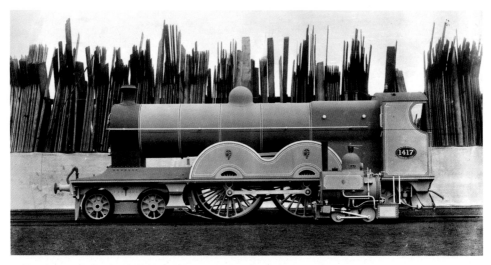

Official works photo showing two Lancashire & Yorkshire Railway steam locomotives. The one, Class 7 4-4-2 No. 1417 was built for passenger traffic at the railway's own Horwich Works in 1902. The class became known as High Flyers as a result of having a high-pitched boiler for better stability when at speed. They all passed into London, Midland & Scottish Railway (LMS Class 2P) ownership in 1923, in the process becoming the only LMS tender Atlantics. The last High Flyer was withdrawn in 1934. Considerably smaller is the railway's 18-inch gauge, 0-4-0 locomotive *Fly* – one of eight Horwich Works yard switchers built between 1887 and 1901. Sister locomotive *Dot* is on display at the National Railway Museum in York. Three of the locomotives were built by Beyer Peacock (BP order No. 6868, works Nos 2823–5, 1887).

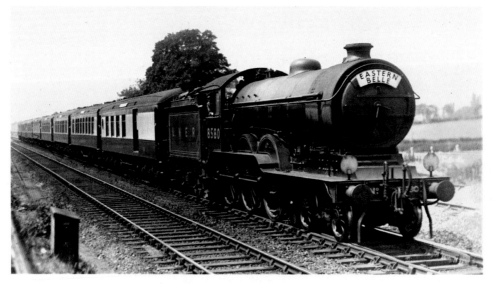

The Eastern Belle was a daily summer season Pullman excursion train which ran from London Liverpool Street station to different holiday destinations along Britain's east coast, such as Felixstowe, Cromer, Sheringham, Clacton and Skegness. The service was provided from 1929 to 1939, and did not resume after the Second World War. London & North Eastern Railway Class B12/3 4-6-0 steam locomotive No. 8580 was built by Beyer Peacock of Manchester (BP 6496, 1924). It became British Railways No. 61580 in 1948, and was scrapped in May 1959.

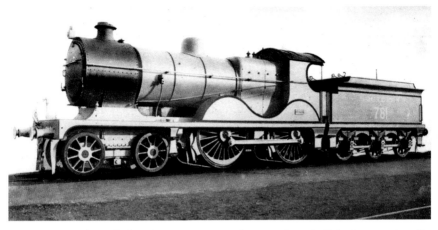

It is common knowledge that most steam locomotives in Britain were locally manufactured. Hardly any orders for new locomotives were placed outside Britain, let alone in Germany. In 1914, however, the South Eastern & Chatham Railway took delivery of German-made express passenger 4-4-0s. They were built partly by Beyer Peacock of Manchester and partly by August Borsig of Berlin. Ten Borsig locomotives were completed just in time before the outbreak of the First World War, supplied in kit form and assembled at Ashford railway works by Borsig employees. The twelve units built by Beyer Peacock were delivered later on, between August and November of the same year. No. 781 became British Railways No. 31781. It was retired after forty-four years in service and scrapped in June 1959.

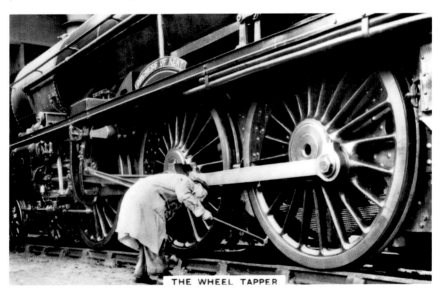

THE WHEEL TAPPER

Little imagination is needed to appreciate the enormous inertia that is generated by the driving wheels of a powerful steam locomotive. Princess Royal Class 4-6-2 steam locomotive No. 46212 *Duchess of Kent* (Crewe Works, 1935) certainly had sizable driving wheels. Measuring 2 meters in diameter, they were still smaller than those fitted to Patrick Stirling's 4-2-2s of 1870, which at 2,464 mm were nearly half a meter wider. To this day, the sound made by tapping on the train's wheels with a steel bar is the easiest way of detecting any dangerous cracks before a more serious damage is allowed to develop.

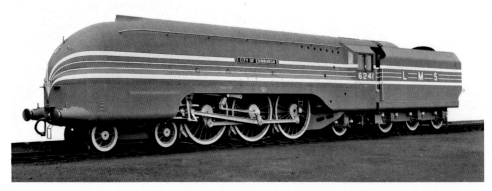

In 1937, five years after taking office as Chief Mechanical Engineer of the London, Midland & Scottish Railway, William Stanier designed a bigger and stronger version of his own Princess Royal express passenger locomotives. The first ten locomotives of Stanier's new Princess Coronation class were provided with a handsome streamlined casing, with five of the locomotives specifically assigned to the Coronation Scot between London and Glasgow. LMS No. 6241 *City of Edinburgh* (Crewe Works, 1940) was one of the streamlined locomotives and in May 1948 became British Railways No. 46241. It was scrapped in February 1965, but three other Gresley Coronations, LMS No. 6229 *Duchess of Hamilton*, No. 6233 *Duchess of Sutherland* and lastly No. 6235 *City of Birmingham*, all survive to this day.

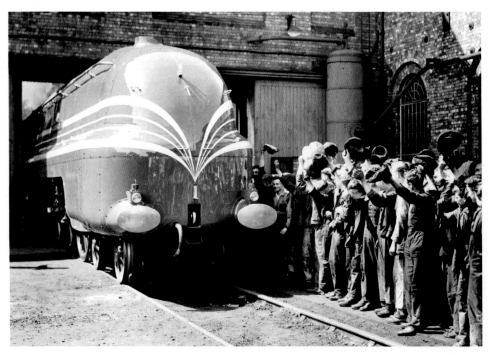

The Princess Coronations were the pride and joy of the LMS. This publicity photo, taken in June 1937, captures the birth of the first locomotive in that class, No. 6220 *Coronation*, upon emerging from the erecting shop at Crewe Works, as jubilant workers celebrate the event. This streamlined locomotive reached a speed of 114 mph and became British Railways No. 46220. It was broken up in May 1963.

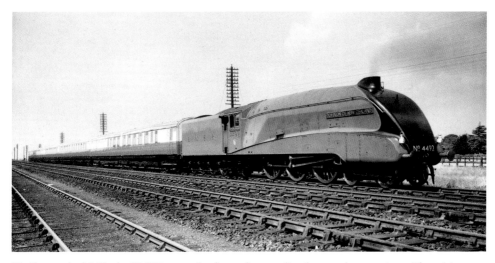

Similar to the LMS, the LNER owned a fleet of streamlined steam locomotives. Class A4 steam locomotive No. 4492 *Dominion of New Zealand* was built in Doncaster Works in 1937, later becoming British Railways No. 60013 in 1949. It was retired and scrapped in April 1963. This photo shows the locomotive with the Coronation, which was an LNER express train between London King's Cross and Edinburgh Waverley. Named to mark the coronation of King George VI and Queen Elizabeth, the Coronation was inaugurated on 5 July 1937 and was based on the Silver Jubilee, another streamlined train. Internally it was decorated in the art deco style.

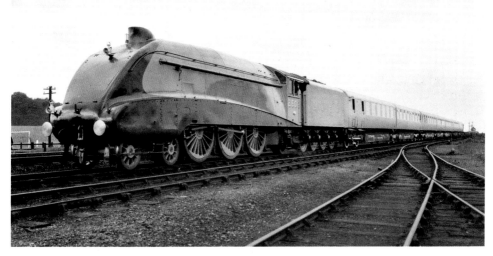

LNER streamlined steam locomotive No. 2509 *Silver Link* (with nameplate located centrally along the locomotive) is seen at the head of the Silver Jubilee express train. Completely new when this photo was taken in 1935, this locomotive later became British Railways No. 60014, which was scrapped on 16 January 1963. It was the first LNER A4 and was regularly coupled to the Silver Jubilee, which started running daily on 30 September 1935. Taking four hours for the London King's Cross to Newcastle journey, the train maintained an average speed of 108 km/h and was painted silver throughout. It was composed of two twin-set articulated coaches and one triplet set, or seven first and third class coaches in total. In February 1938, an eighth coach was added to the third-class twin set. The service continued until the outbreak of the Second World War in 1939.

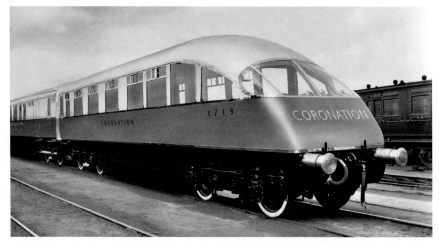

In 1937, LNER-built two beavertail observation vans at its Doncaster Works for use on the Coronation express passenger train during the summer months. Looking quite different to the teak coaches, they resembled the A4 locomotives that hauled the train. These coaches had a conventional corridor connection at one end and a glazed tapered end at the other. They were fitted with a luggage compartment, a luxury bar and a lounge. Both coaches were placed in storage during the Second World War. In the post-war years, the vans never ran as a full set again. The observation cars were transferred to the West Highland line in 1956. Their original observation end was found to give a limited view, and British Railways rebuilt them with a more angled end and added larger windows, running in this form from 1959 to 1968.

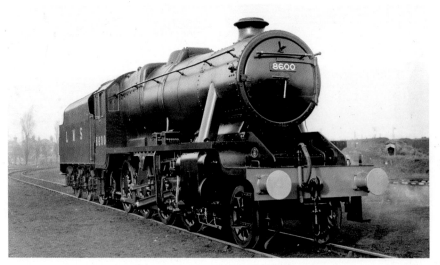

The locomotive that helped win the war', LMS Class 8F No. 8600 was actually built at the Southern Railway's Eastleigh Works in February 1943 due to a wartime need for freight locomotives and other war work preventing the LMS workshops from building enough of them. During the Second World War, Eastleigh Works built twenty-three of these 2-8-0s. No. 8600 became British Railways No. 48600 in August 1948. It was retired in 1966 and scrapped in May 1967, after twenty-three years and ten months of faithful service.

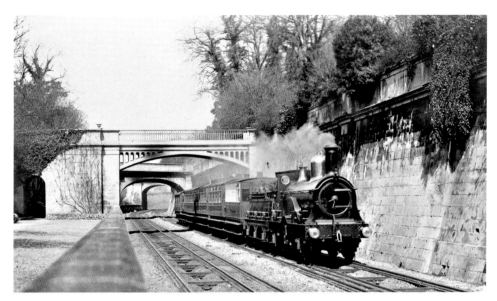

Originally known as Bath Vauxhall Gardens, Sydney Gardens is a public park at the end of Great Pulteney Street in Bath, England. They are the only remaining eighteenth-century pleasure gardens in the country, and are listed on the Register of Historic Parks and Gardens of special historic interest in England. This photo is dated to the period between 1874 and 1892, when the track from Bathampton to Bristol was still dual gauged. A Bristol-bound Great Western Railway standard gauge passenger train is seen passing through the gardens, under the command of a Queen Class 2-2-2 locomotive. These locomotives worked express trains for almost thirty years, and were the predecessors of the William Dean's larger Singles.

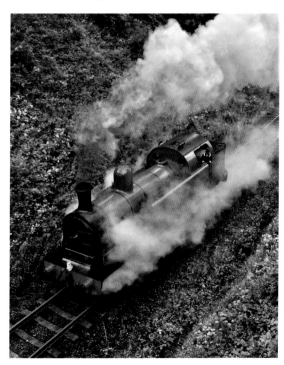

One of Britain's longest-working steam locomotives, Lambton Tank No. 29 travels through Darnholm Curve between Grosmont and Goathland at the North Yorkshire Moors Railway. The 0-6-2T was built by Kitson in 1904 for the Lambton Railway and used at the Hetton and Joicey collieries until their closure in 1967. Note the locomotive's rounded cab profile, which enabled it to work through a tunnel with restricted clearance to reach the Lambton Drops at the Port of Sunderland. No. 29 was taken over by North Yorkshire Moors Railway in 1970 and is kept in full running condition. (Photo by Colin Alexander)

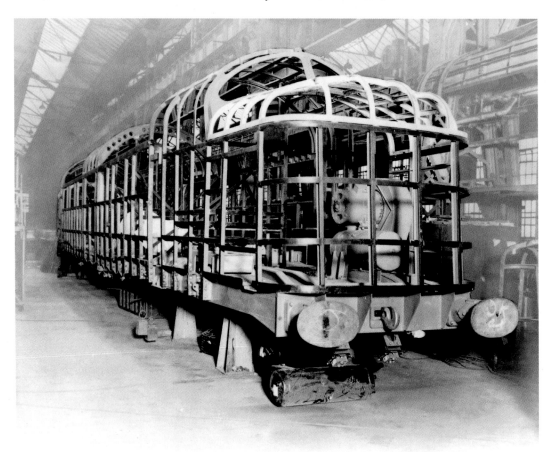

The English Electric DP1, better known as the Deltic, was a prototype 3,300 hp demonstrator locomotive built in 1955 and equipped with two Napier diesel engines. The locomotive's high output and low axle load resulted in twenty-two similar locomotives being ordered by British Railways for use on the East Coast Main Line express passenger services. In serial production, these locomotives became BR Class 55. In 1961, when the first production units were nearing completion, the prototype Deltic was returned to English Electric after having travelled more than 400,000 miles. On 28 April 1963 it was received at the Science Museum in London, and is currently on permanent display at the National Railway Museum in York. In contrast to the many familiar views of this famous diesel locomotive, this photo shows the prototype's bare frame while still under construction.

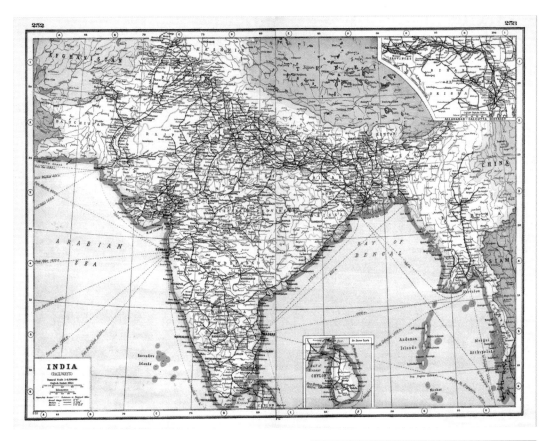

Above: British India Railway map.

Right: A leading element of Britain's colonial rule in India was the creation of a huge railway system all over the Raj. Stretching over thousands of miles from the Indian Ocean in the south to the Himalayas in the north, the railways of British India relied on a steady supply of British-made steam locomotives to meet the needs of the various railway companies. This Armstrong Whitworth advertisement appeared in the Indian press in 1930 to promote the Elswick, Newcastle-based manufacturer's range of products. A powerful image of a rushing steam locomotive, painted in black on a dramatic red background, conveys a sense of speed and strength.

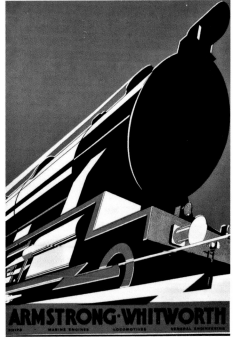

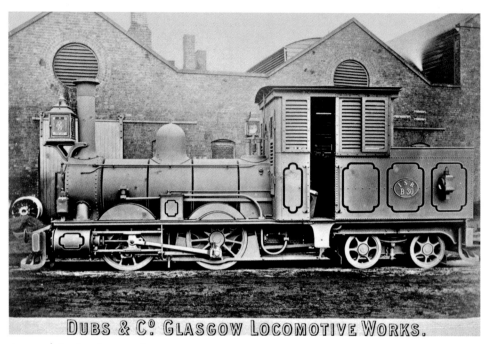

An example of early steam locomotives in British India is Indian State Railways 0-4-4T No. B30. This tiny locomotive (Dübs locomotive Works 745, 1874) became Rajputana State Railway No. 99, in itself operated by the Bombay, Baroda & Central India Railway. Glasgow-based Dübs merged in 1903 with Sharp Stewart and Neilson Reid to form the North British Locomotive Company.

The Indian Midland Railway was established in 1885 to manage several existing broad gauge lines around the city of Jhansi, in the Allahabad Division of the United Provinces. It was amalgamated in 1900 with the Great Indian Peninsula Railway. In 1899, ten 4-4-0s were built for the IMR (Kitson 3886–3895). They were named after cities connected with the railway. The first of these, No. 251 *Cawnpore*, was followed by *Agra, Jhansi, Manikpur, Bina, Itarsi, Bhopal, Gwalior, Mahoba* and the last one, No. 260 *Dholpur*. They became GIPR Class B1 1251–1260 following the takeover in 1904.

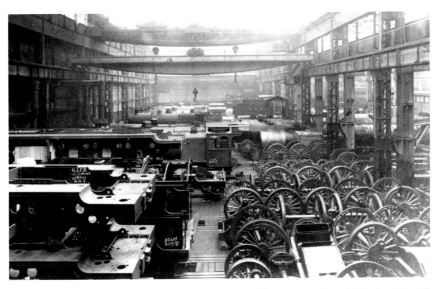

A look inside the North British Locomotive Works construction hall, showing all manner of steam locomotives and tenders in various stages of construction for the Great Indian Peninsula and the Madras & Southern Mahratta Railways companies. Locomotive driving wheels are visible on the right side.

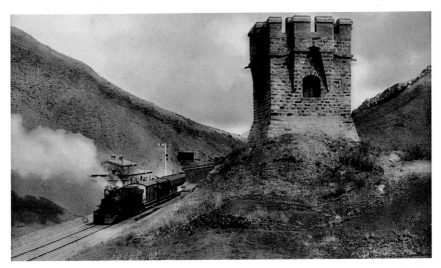

The province of Baluchistan is an arid and mountainous region in Asia. Today in Pakistan, it was a British-administered area that was strategically located in the vast territory between British India and Afghanistan. A British military base was established at Quetta. The Sibi–Harnai–Quetta railway line was the first to successfully connect Quetta with the rest of British India. The line was part of a broader British military plan to defend India from a possible attack by the Russian Empire after the Second Afghan War of 1878. It was proposed that military roads and railway lines should be built through the frontier passes connecting India with Afghanistan, such as the Khyber and Bolan Passes. Accordingly, the first train steamed into Quetta in 1887. In a classic scene from the days of the British Raj, a passenger train travels through the barren wasteland that is Baluchistan. Protecting the line is a massive fort of the British Indian Army.

LONDON TO BOMBAY IN A WEEK: THE PROPOSED £21,000,000 RAILWAY.

DRAWN BY W. H. ROBINSON.

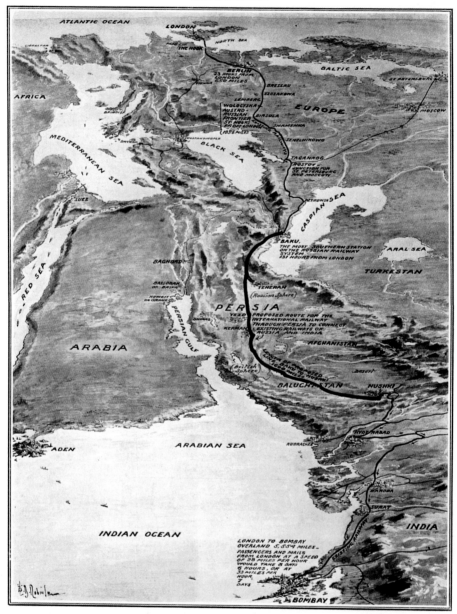

LINKING UP RUSSIA AND INDIA: THE SUGGESTED INTERNATIONAL LINE THROUGH PERSIA, CONNECTING THE RAILWAYS
OF RUSSIA AND INDIA.

M. Zvegintzeff, a member of the Duma, has stated that a number of Russians interested in financial and railway enterprise have decided that the time is ripe for the uniting of the lines of
the European railway system with that of India. They propose to start from Baku, the southernmost station on the Russian system, and to take a direct line through Persia to Nushki, on
the Anglo-Indian system. The length of line required to connect the Russian and Indian lines is 1600 miles, and it is said that the total expenditure called for would be £21,000,000.
It is claimed that if the proposition be carried out, it will be possible to take passengers and mails from London to Bombay in eight days six hours; that is to say, at an average speed of

International railway lines have always been the hallmark of the colonial era. This map was
published in 1910, showing the proposed London to Bombay railway, with connection to
Russia. The journey to India was expected to take up to eight days over a total distance of 5,554
miles via Berlin, Baku and Baluchistan.

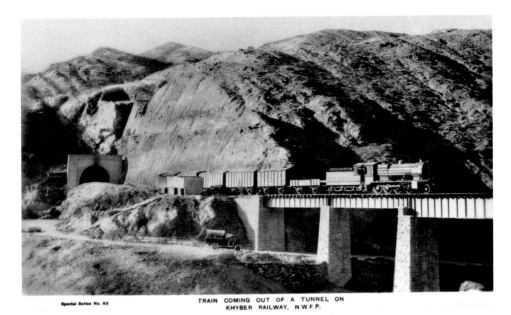

Special Series No. 62 TRAIN COMING OUT OF A TUNNEL ON
KHYBER RAILWAY, N.W.F.P.

The Khyber Pass is a mountain route linking Pakistan with Afghanistan. Throughout history it has been an important trade route between Central and Southern Asia and a strategic military location. This postcard is dated to the conclusion of the third Anglo-Afghan war of 1919, and shows a train coming out of a tunnel on the Khyber Pass Railway, NWFP (North Western Frontier Province).

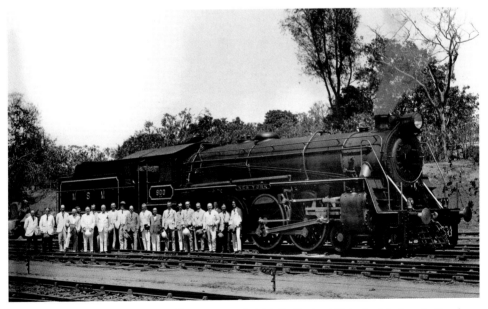

Non-British locomotives were seldom seen in British India. In 1924, the Madras & Southern Mahratta Railway took delivery of four Baldwin steam locomotives that were imported to India for experimental reasons. Two of the locomotives, MSMR 4-6-2 No. 900 (BLW 57738) and No. 901 (BLW 57739), were named New York and Philadelphia.

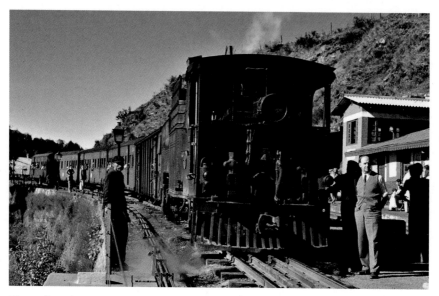

The Kalka–Shimla Railway is one of India's best known mountain railways. Located in the far north of the country, the KSR (762 mm gauge) is famous for the dramatic views of the scenery on the steep climb to the summit station. The line was built between 1898 and 1903 to connect Shimla, British India's summer capital, with the rest of the Indian railway system. The first steam locomotives arrived from Sharp Stewart, with diesels placed in service since 1955. In 2008, the Kalka–Shimla Railway was declared a UNESCO World Heritage Site. This photo, taken nearly sixty years ago, in 1958, shows KSR Class K 2-6-2T steam locomotive No. 4 and its passenger train at Shimla station. No. 4 was built in 1910 by the North British Locomotive Works as NBL 19182.

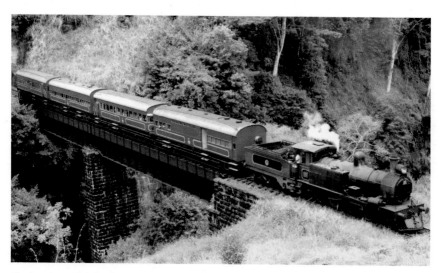

Ceylon (now Sri Lanka) was once governed by Britain and the island's railway system was naturally affiliated with that of British India. No longer a colony, steam heritage trains continue to run there even today. On 22 March 1990, Ceylon Government Railways No. 213 (Vulcan Foundry 3555, 1922) crosses a bridge with a brightly colored passenger train, near Galboda Tunnel, to the east of Colombo.

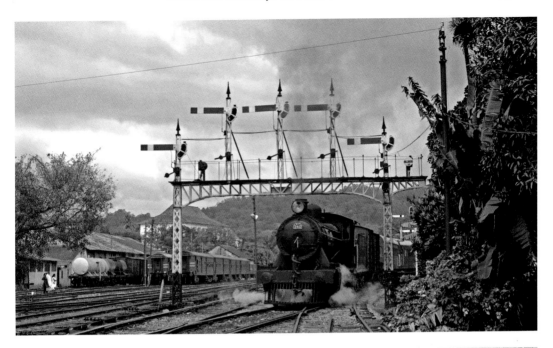

Right and above: Two recent photos from Sri Lanka in 2018. Ceylon Government Railways Class B1D No. 340 (Robert Stephenson 7155, 1944) passes the Lion's Mouth rock formation on the Colombo–Kandy mainline between the stations of Balana and Kadugannawa. The second photo shows No. 340 at Kandy, on the approach to the signal gantry, which protects the entrance to the station. (Both photos by Helmut Dahlhaus)

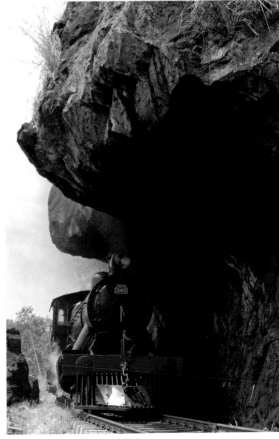

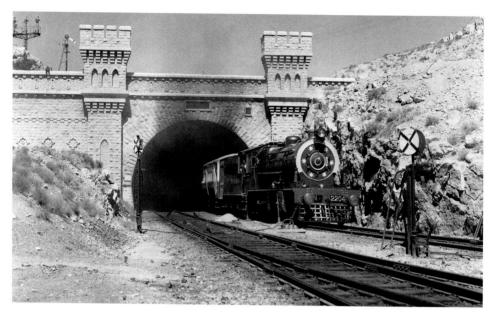

Steam trains are long since gone from the Bolan Pass. In 1970, a smartly turned out ex-North Western Railway HGS Class 2-8-0 locomotive – Pakistan Western Railway No. 2204 (Kitson Locomotive Works, Leeds, 5092, 1914) – emerges from an ornate summit tunnel entrance at Kolpur with a passenger train.

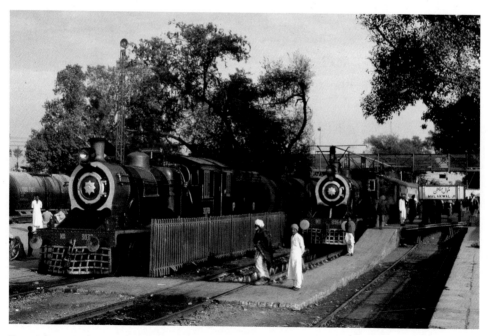

Steam locomotives remained in service in Pakistan long after the end of the Raj and the nationalization of the railway system. These two veterans, No. 3078 (Beyer Peacock 4612, 1904) and No. 2964 (Vulcan Foundry 2771, 1911), appear to be in good condition for their age and perfectly fit to haul both passenger and freight trains.

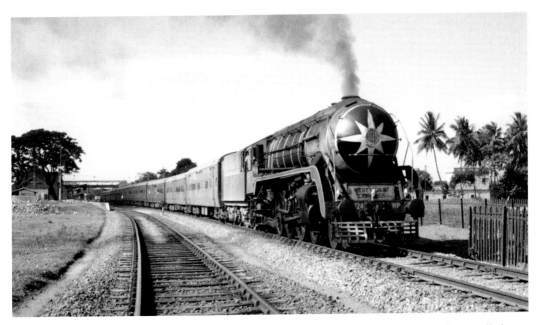

Steam reigned supreme also in India for many years after Britain's departure from the so-called jewel in the crown of the British Empire. Indian Railways Class WP steam locomotive No. 7724 is seen in 1968 with the West Coast express train. It was built locally, in Chittaranjan Locomotive Works, in 1966.

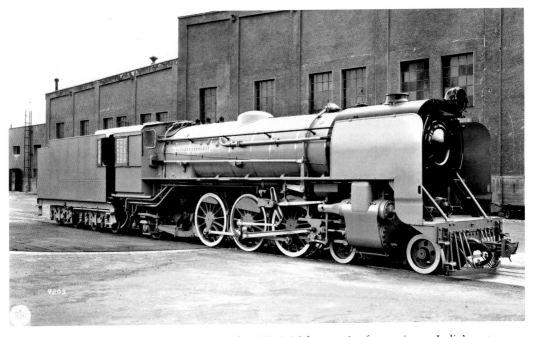

Official Krauss Maffei photo of a new Class YP 4-6-2 locomotive for service on India's meter gauge railway system. Fifty such locomotives were built in Munich for service in India and delivered in February 1955 (KM 17991–18140). Their Indian Government Railways numbers were 2171–2320. In total, 200 YP locomotives were ordered from the German manufacturer.

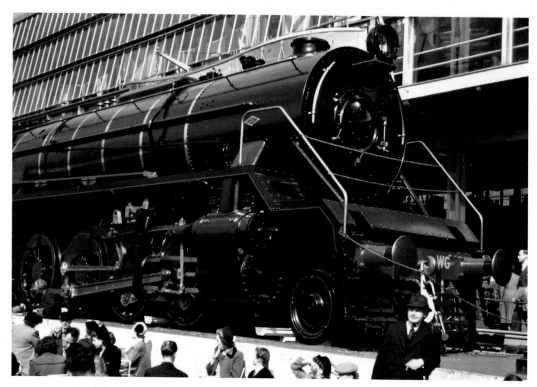

Above: The 1951 Festival of Britain was in some ways in the tradition of the Great Exhibitions that were held in London in the previous century. The area of London to the south of the River Thames had been totally obliterated by German bombs in the Second World War, but there was no private investment to clear the site and rebuild the area. It was a huge eyesore, and the government was faced with paying for the clean-up out of public funds. They chose an event combining a fun fair with notable examples of British industry and scientific achievement. After the exhibition ended, all of the new buildings were controversially demolished and the site became the South Bank complex, including the Royal Festival Hall.

The Indian Class WG (broad gauge) may have the distinction of being the largest and most widely manufactured type of locomotive in the world, with a total of 2,450 units built in Britain, Germany, Austria, USA, Japan, Switzerland, and, finally, India between 1950 and 1970. Indian Government Railways Class WG 2-8-2 steam locomotive No. 8350 (North British Locomotive Works 26463, 1950) was placed on public display at the festival. To this day, this is the only color photo known to have been taken of the locomotive during the event.

Opposite above: The WCM/5 was a watershed locomotive for the Indian Railways, being the first locomotive of any kind fully developed and built in India, and Incorporating the best of the previous models. It had a larger body, regenerative brakes and improved pantographs. This type was the mainstay of the Mumbai area up to the 1990s, hauling important express trains such as the Deccan Queen. The first WCM/5, No. 20083 *Lokmanya* (Chittaranjan Locomotive Works, 1961) was also the first of twenty-one Indian-made electric locomotives. It was eventually scrapped, but sister locomotive No. 20103 is on display in New Delhi.

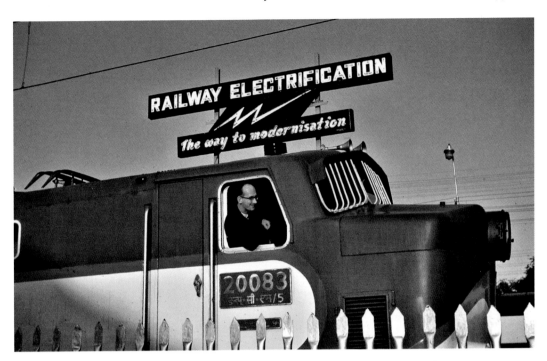

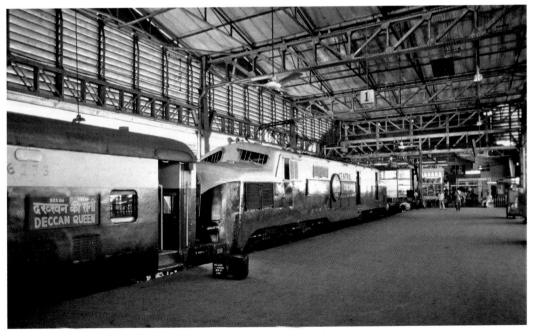

Central Railway of India Class WCM/1 electric locomotive No. 20070 with the Deccan Queen passenger train in 1981. They were India's first mainline, mixed traffic electric locomotives, and all seven were built by English Electric and Vulcan Foundry in 1954 to replace older models on express trains to Pune and Igatpuri. They had diamond-shaped current collectors and a cabin door that was strangely located in the middle of the locomotive's side. Many were rebuilt in 1968 with a more properly placed cab door.

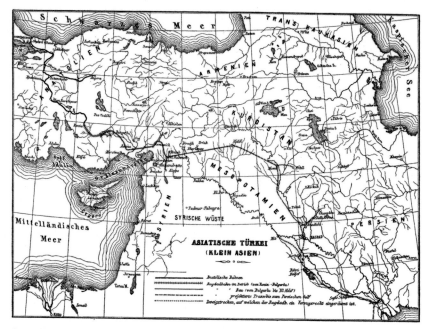

The Baghdad Railway.

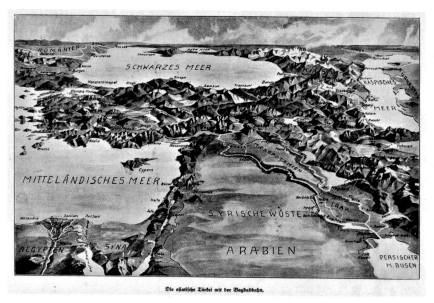

Much has already been said and written about the Bagdadbahn, which started off as a somewhat romantic fantasy to link Berlin with Baghdad (then in Mesopotamia, today in Iraq). Stretching from Europe to the Persian Gulf, the line would have been useful in promoting German military and financial interests in Asia. This detailed map, issued before the First World War, follows the Baghdad Railway from Eastern Europe into Asiatic Turkey and the Middle East. Connections to other destinations in Asia, namely the Hedjaz Railway to Arabia, are also shown, accurately illustrating the challenging topography in this part of the world.

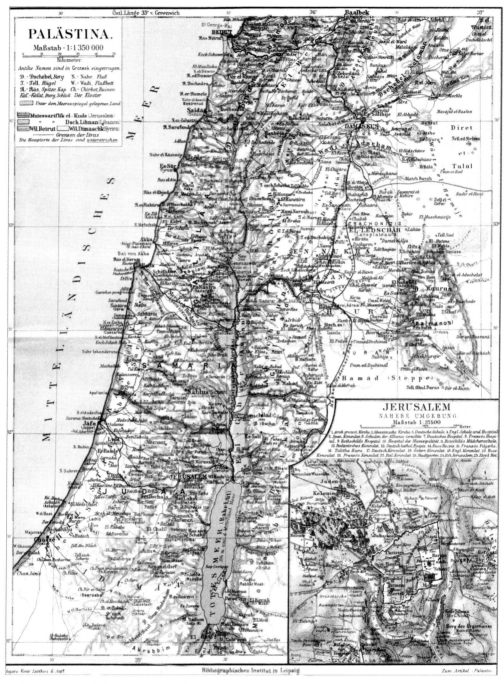

A 1910 map of the territories administered by the Turkish Ottoman Empire in the Levant, showing the three narrow gauge railway lines running inland from the Mediterranean Sea to the east. The first line links Jaffa with Jerusalem, the Hedjaz Railway runs from Haifa to the Sea of Galilee and Deraa Junction, and in Lebanon, the third line ascends from Beirut to Rayaq and Damascus. The northern section of the Hedjaz line ('Mekka Bahn') is clearly visible, as it descends from Damascus in the north towards Amman in Jordan.

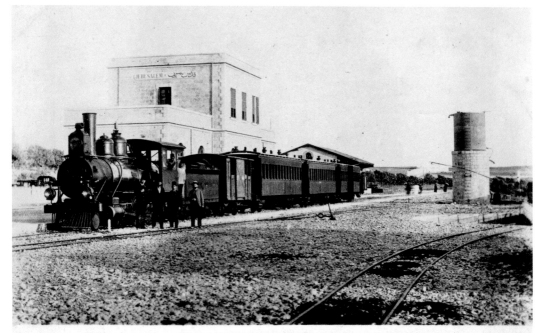

No 13. Jerusalem Railway Station.

Above: The Jaffa & Jerusalem Railway was the first railway in the Holy Land, at that time a tiny province within the Turkish Ottoman Empire. Inaugurated in 1892, the line was built first and foremost for the benefit of Christian pilgrims making their way to Jerusalem from the small port of Jaffa, today in the south of Tel Aviv. Originally of meter gauge, in the First World War the line was upgraded to standard gauge during the British advance from Egypt northwards to Haifa. J&J 2-6-0 steam locomotive No. 4 *Lydda* (Baldwin Locomotive Works 12585, 1892) has reached Jerusalem station with a train made of one baggage van and three coaches. Both station and train were new when this photo was taken.

Opposite above: The Port of Jaffa was for many centuries the Holy Land's main outlet to the Mediterranean Sea. It has since then been replaced with modern and bigger ports in Haifa Bay, afoot Mount Carmel, and in Ashdod, on the coastline to the south of Tel Aviv. Jaffa railway station was built only a short walk from the seafront and the port area, to carry passengers up the Judean hills to Jerusalem. This photo shows a Jaffa & Jerusalem Railway passenger train, again made of 3 meter gauge coaches and a baggage van, parked next to the main platform. Absent from the photo are the railway's Baldwin and Borsig steam locomotives, which were sabotaged during the Turkish retreat from the Middle East in the First World War. Jaffa station has since then been abandoned and today serves a new purpose as a fashionable shopping and recreation area, using the same station building.

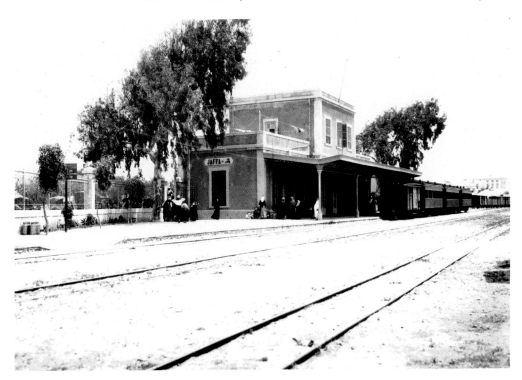

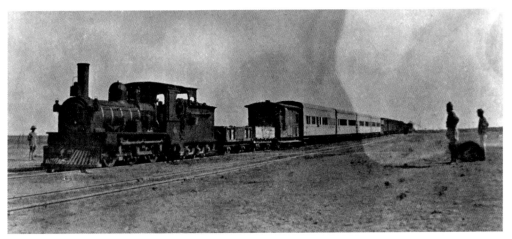

A First World War British military train in Iraq. The photo, which was water-damaged in the intervening years, shows a Bombay, Baroda & Central India Railway (meter gauge) Class F locomotive and carriages. These little 0-6-0s were gutsy in the extreme, and could haul big loads on the flat terrain of Mesopotamia. Possibly a hospital train, or an unusually long mixed train made of one steam locomotive, two water tanks, ex-BBCIR passenger brake van coupled to four coaches, and finally a heap of vans. Mention should be made of the locomotive. Up to 1886, meter gauge locomotives for India's various railways were ordered in bulk. This resulted in fewer locomotive types, of which the F class became the most popular. Introduced in 1874 and modified in 1884, this type remained in production until 1922, reaching a total of 871 locomotives. The first locomotive built in India in 1895 at the BBCIR Ajmer workshops belonged to this class.

The Hedjaz Railway was a Turkish Ottoman narrow gauge (1,050 mm) railway system in the Middle East. Completed in the years preceding the First World War, it was built on religious grounds, to carry Mecca-bound Muslim pilgrims from Damascus and Amman to the holy city of Medina, in Arabia. The Hedjaz (meaning 'barrier' in Arabic and so named after a mountain range in Arabia) also served the military needs of the Turkish Army during the war. Both of its southern sections, on each side of the Jordan Valley and the Dead Sea, were destroyed during the war at the hands of Lawrence of Arabia in the east and ANZAC units in the west, between Beersheba and Sinai. This Hedjaz Railway picture shows a 2-8-0 steam locomotive, built by Krauss of Munich and Linz (Austria) at Mudawara station, on the main line between Amman in Jordan and Arabia. Additional water tanks were needed for the long voyage into the dry Arabian Desert. The photo probably dates from around 1906, based on the missing steel tanks on the water tower and the absence of a station building.

The Hedjaz Railway extended from Deraa Junction, on Syria's border with Jordan, westwards to Haifa Bay. The train ride over this part of the line involved a journey through some of the most spectacular landscape imaginable. The rough and rugged terrain in the railway's path required the use of several tunnels and bridges along the Yarmuk Gorge, to the east of the Sea of Galilee. Clearly marked in the hills above and to the left of the Yarmuk River, the Hedjaz Railway Bridge is at the center of this photo from the 1930s. The Yarmuk Bridge was sabotaged and today the line remains completely abandoned, though far from forgotten.

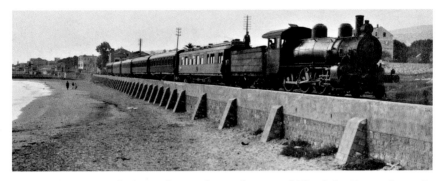

Not Dawlish, but Haifa during the British Mandate period. The Cairo Express is seen in Haifa, on the first leg of the long journey into the Sinai Desert, and over the Suez Canal, to Egypt. Heading the train is a Palestine Railways (ex-War Department) Class H 4-6-0 steam locomotive. Originally numbered WD 871–920, the first ten in a total of fifty Baldwin locomotives arrived in Palestine in 1919 and the remaining forty followed in 1920. This photo, or one similar to it, appears also in a Palestine Railways ad issued in 1922. However, unlike the ad photo, this train seems to have been stopped specifically for the photo. Note the driver leaning out of the window; the fireman standing on the tender; the gentleman sitting on the wall and looking right at the camera; the passengers on and near the Wagons Lits coach; and finally, the lack of any smoke from the locomotive's chimney.

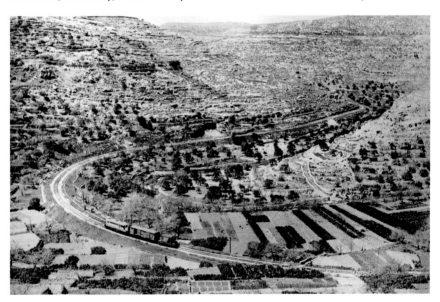

The State of Israel was established in 1948, in the wake of the British Mandate in Palestine. It was immediately invaded by its Arab neighbors, who were dealt a humiliating defeat in Israel's war of independence. However, East Jerusalem and the Samaria and Judea regions remained under hostile Jordanian control for the time. This included also a short section of the Jerusalem line. A neutral corridor was therefore established on both sides of the track, separating the Israeli and Jordanian forces, and providing a safe passage for four trains a day. The short train in this photo is made of a General Motors (EMD) diesel locomotive with only one boxcar and a Southern Railway van on what could be an Israeli test train through unsafe territory. The political situation changed dramatically following the Israeli victory in the Six Day War of 1967, finally opening the entire line for uninterrupted traffic.

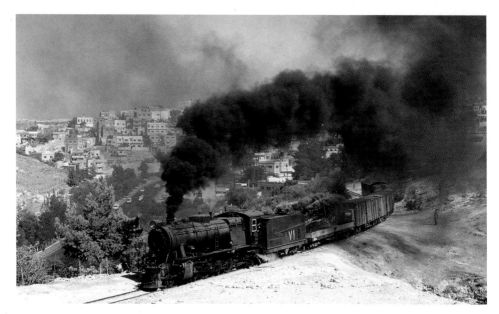

The Hedjaz Railway originally belonged to the Ottoman Empire. When the empire was dissolved after the First World War, the Hedjaz system was separated into several successor railways. The Hedjaz Jordan Railway, to the south of Syria and to the east of the Jordan River, became the state railway of the Hashemite Kingdom of Jordan. New steam locomotives were ordered in the 1950s to operate in Jordan. HJR 2-8-2 No. 71 arrived from Forges Usines et Fonderies Haine Saint Pierre in 1956, with the HSP works number 2144. It was photographed with a mixed train in Amman as late as 1997.

The Hedjaz Railway terminal in Damascus is a fine example of oriental architecture, and historically the starting point for southbound trains to Jordan and Arabia. The recent war in Syria and the political instability in whole parts of the Middle East have crippled the Syrian railway system. Hedjaz Railway passenger coach No. 239 stands in the sun outside the station building. It was built by Baume & Marpent in 1910 and appeared to be in excellent condition when this photo was made in 1965.

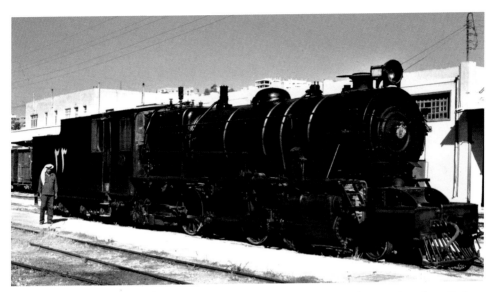

The Hedjaz Jordan Railway bought three new oil-fired 2-8-2 steam locomotives from Robert Stephenson in 1952 (RSH 7431–33). Numbered HJR 21–23, the last of them was at Amman station in 1980. Technically identical to the Indian YD type, they were shipped fully built to Lebanon and unloaded at the Port of Beirut. They were then hauled to Damascus via Rayaq, in the Lebanese mountains, and sent from there to Amman.

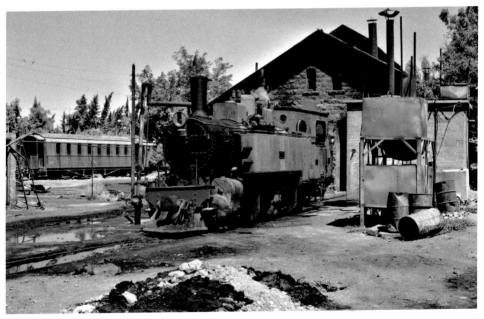

Battered parts, bins and oil drums, ash heaps, puddles and a delightful coach in the background all create a wonderful atmosphere in this photo of Damascus Cadem Shed (Syria) in 1980. Chemins de Fer Syriens 0-4-4-2T No. 962 was built by Sächsische Maschinenfabrik Richard Hartmann of Chemnitz more than a century ago (Hartmann 3001, 1906). The Hedjaz Railway received two such Mallett locomotives, the other being HR 61 (later CFS 962). Both were taken over by Syria and have been out of service for many years.

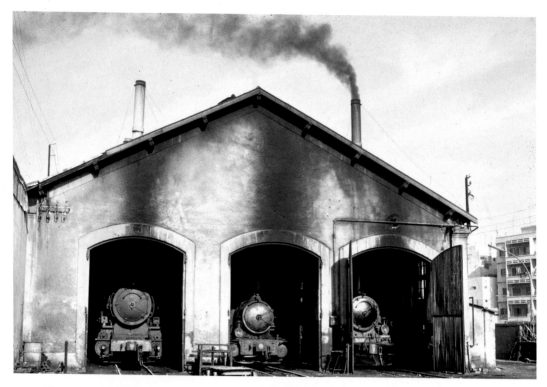

Above: In 1891, a French company obtained a concession to build a railway from Beirut to Damascus. Formed in Paris, the Societè des Chemins de fer Ottomans Economiques de Beyrouth-Damas-Hauran at first planned an adhesion line, but the difficulties involved in ascending the mountains above Beirut resulted in the adoption of the Abt rack system for a part of the route. The gauge finally chosen was 1,050 mm. The railway operated a fleet of Swiss-built steam locomotives, three of which are seen in Beirut in 1968 and under the later ownership of the Chemin de fer de l'État Libanais. They are, left to right, a Class S 0-10-0T (CEL 301–307/SLM, 1924–1940); Class B 0-6-2T No. 8 (SLM 848, 1893) and on the right, Class A 0-8-2T (CEL 31–37/SLM, 1906). CEL 34 is known to have had a snow plough in January 1972. Lebanon's railway system was destroyed in a civil war and no trains run there anymore.

Opposite above: The Iraqi State Railways PC Class was made of four standard gauge streamlined passenger steam locomotives. In 1941, a year after the long overdue completion of the Baghdad Railway all the way to Syria, four new 4-6-2 locomotives were ordered from Robert Stephenson & Hawthorns to haul the Taurus Express train into Iraq. Externally, these locomotives resembled the LMS Coronation Class and as well as LNER's Class A4. Inside, they had smaller driving wheels with a diameter of 1,753 mm, similar to British mixed traffic locomotives. All four were named after Iraq's four main cities – Baghdad, Mosul, Basra and Kirkuk. No. 502 *El Mosul* was the first to be delivered, in March 1941. The last one, No. 504 *Kirkuk*, was lost en route and never entered service in Iraq. This official Robert Stephenson Locomotive Works photo of Iraqi State Railways Class PC No. 502 *Mosul* (RSH 6983, 1940) bears the signatures of the erecting shop manager Andrew Edward Whitfield (seen in the photo in front of the locomotive) and his workshop assistants.

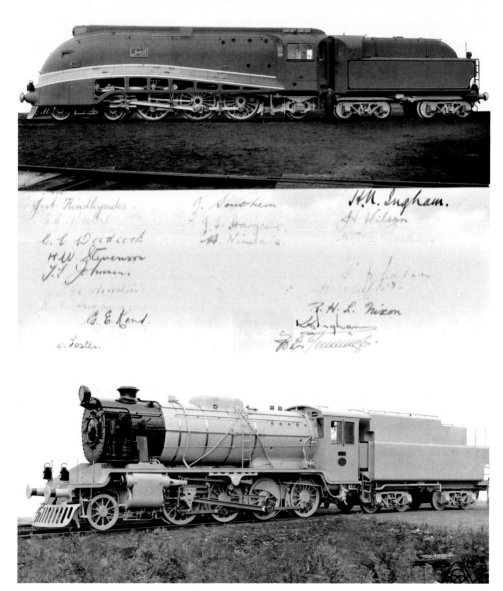

The reader is excused for confusing the 2-8-0 locomotive in this photo with the famous LMS 8F. William Stanier's locomotive had gained good reputation in the Middle East during the Second World War, with many locomotives of this class entering regular service in Egypt, Israel, Turkey and Iraq after the war. When the time arrived to place orders for new steam locomotives, the type's good performance and reliability were taken into account. The result was non-British steam locomotives that were clearly modeled after the 8F. Iraqi State Railways Class TE No. 1441 was one of seven locomotives constructed in Germany by Krupp of Essen in 1956. They became Iraqi State Railways 1441–47 (Krupp 3585–3591, 1956).

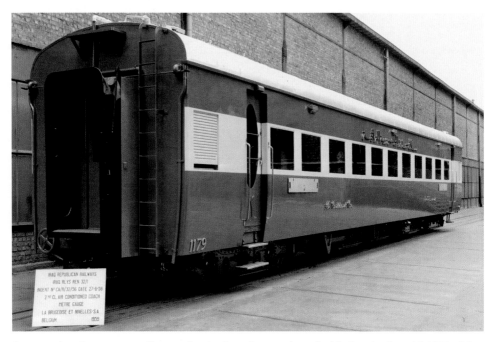

A comprehensive passenger fleet modernization plan was launched in Iraq in the mid-1950s. New coaches were imported into the country from Britain, Belgium and Germany. La Brugeoise et Nivelles second-class coach No. 1179 was delivered to Iraq's meter gauge railway system in 1959. With its large oval door windows and air conditioning, it was a major improvement for Iraq's passenger trains.

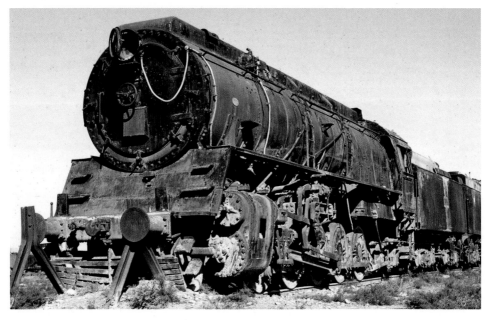

Sixty-four Vulcan Foundry steam locomotives were supplied to the Iranian State Railways in 1952–53. These massive Class 52 2-10-2s, weighing 175 tons, were the most powerful locomotives ever sent to the Middle East, and were destined to haul heavy freight trains on the Trans Iranian Railway. Stored at Ahwaz, in south-western Iran in 1968, and in poor condition, a rusty Class 52 locomotive is nearing the end of its life in the company of other steam locomotives.

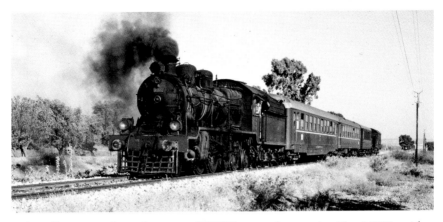

A friendly gesture from the crew of TCDD steam locomotive No. 46102, with a local train to Torbali, in the Turkish province of Izmir, in 1977. Six of these Robert Stephenson 2-8-2 locomotives were built for the Ottoman Railway Company in 1929 and 1932 (RSH 3993–6 and 4073/4). They became TCDD 46101–106. No. 46103 is on static display at the Çamlık Railway Museum.

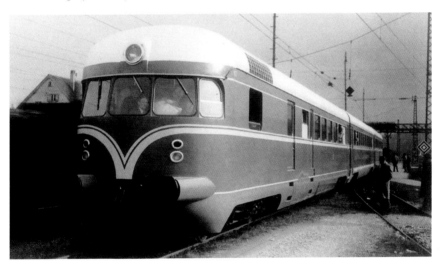

The 1950s were a period of transformation for the railways of Israel. The formal signing of the Reparations Agreement between Israel and the Federal Republic of Germany on 10 September 1952 resulted in a large volume of German-made goods that were delivered to the young State of Israel in compensation for the Holocaust. Starting in 1956, Israel State Railways were presented with twelve self-propelled diesel trains that were built jointly by the German companies of Maschinenfabrik Esslingen, Waggon-und Maschinenbau Donauwörth and Linke Hofmann Busch. The Israeli trains were largely modeled after the German Federal Railways' own Class VT 08 DMUs depicted previously in this book. Due to a combination of mechanical problems, inadequate use and improper maintenance, and only a few years after entering service in Israel, all twelve trains were downgraded to ordinary, locomotive-hauled coaches. They were ultimately withdrawn in 1979. A brief revival occurred in the nineties, when seven intermediate coaches were renovated and temporarily reinstated following a rise in the demand for passenger trains in Israel. The Esslingen trains were scrapped, save for one set which is on permanent display at the Israel Railways Museum in Haifa. This photo, taken in Germany, shows an Esslingen diesel train undergoing a test run prior to delivery to Israel.

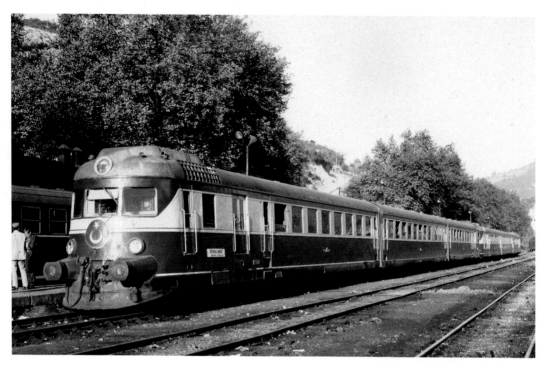

Above: Similarly full of class and character were the West German diesel trains that were supplied to Turkey in 1951 and 1952, and were also closely related to the German VT 08 type mentioned previously. Again built by Esslingen, with MAN and DÜWAG, the sixteen TCDD trains were designated as MT5300. They were powered by two motors giving a combined output of 1,100 hp and had a top speed of 125 km/h. The MT5300s were designed for express service and were equipped with a dining room, a bar and a small kitchen. Standing at Çatalağzı station in 1977, in a double formation requiring the use of all four motors, is a pair of TCDD Class MT5300 DMUs. This Ankara-bound diesel train had only a year to go before reaching the end of its useful life in Turkey. Having lost their motors and hydraulic transmission units, all sixteen trains were henceforth coupled to diesel and sometimes even steam locomotives. They were retired shortly afterwards and scrapped. None was kept for preservation.

Opposite above: At around five o'clock on a wet afternoon in 1964, TCDD Class MT5300 diesel train No. 5305 (DÜWAG & Westwaggon, 1951) pulls into Istanbul's Haydarpasa station, on completion of the nine hours, 576 km long journey from Ankara with the Bogazici Ekspres (Bosphorus Express). The grand, castle-like Haydarpaşa station building seen in the photo was built in 1909 by the Anatolian Railway (CFOA) as the western terminus of the Baghdad Railway. It has since then been damaged in fire and today remains as an Ottoman era monument in the Asian side of Istanbul.

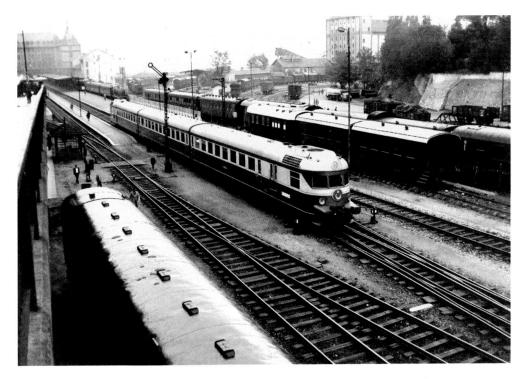

In the 1920s, The London-based Brazilian Plantations Company decided to develop the land in the northern part of the Brazilian state of Paraná. This included the construction of a new and mostly agricultural railway line out of the city of São Paulo. On 21 August 1929, the surveyors in charge of the line reached Três Bocas (today in Londrina), but the project was delayed due to the 1929 financial crisis. It was nonetheless successfully completed, private land was auctioned and the first farms were built as planned. Named Companhia Ferroviária São Paulo-Paraná, or SPP, the new railway company was a customer of the William Bagnall Locomotive Company. SPP 2-8-2 No. 21 was built by Bagnall of Stafford in 1935 and is here seen in the manufacturer's ad from the 1950s.

BUILDERS OF LOCOMOTIVES FOR THE WORLD'S RAILWAYS

Supplied to the São Paulo-Paraná Railway, Brazil, this 2-8-2 main line locomotive weighs 95½ tons with separate tender and has a tractive effort of 27,616 lb.

W.G. Bagnall LTD.

W. G. BAGNALL LTD. CASTLE ENGINE WORKS STAFFORD

Four-cylinder Compound Locomotive, Mallet System — Dutch State Railways of Java

Above: Previously known as Dutch East Indies, most of Indonesia's railways were constructed during the colonial era. The first line was opened to traffic in August 1876 under the Nederlands Indische Spoorweg Maatschappij, with additional lines added in the following years. Next to come was the state-owned Staatsspoorwegen, the railway system approved by the Dutch Ministry of the Colonies. When Indonesia became independent in 1949, nearly all of the various systems were brought under a central administration. Finally in 1963, all Indonesian railway lines were nationalized and renamed Perusahaan Negara Kereta Api, or PNKA (State Railway Corporation).

In 1928, the Staatsspoorwegen placed an order for medium weight Mallett locomotives with the Swiss Locomotive and Machine Works of Winterthur and the Dutch locomotive and rolling stock manufacturer Werkspoor. Smaller than the existing 2-8-8-0 Malletts, the new locomotives were the last Malletts ever ordered for this railway and were intended to haul heavy trains on the mountain lines of western Java, with a lower axle load. As an extra caution, they were equipped with the Riggenbach compression brake on top of the usual vacuum, steam and hand brakes. They had a top speed of 60 km/h. Later designated as PNKA Class CC5000, one of the originally Staatsspoorwegen Malletts is portrayed in an SLM Winterthur catalogue from 1937.

Opposite above: This Dutch East Indies Railways travel poster shows a romantic illustration of the Staatsspoorwegen Java Night Limited train speeding under a full moon and a starry night. On 1 May 1929, the railway line was completed between Yogyakarta and Surakarta, cutting the total travel time between Batavia (today called Jakarta) and Surabaya to less than twelve hours. The day train, called the Eendaagsche Expres, had an average speed of 72 km/h on this route. On 1 November 1936, a night express was introduced. Hailed as 'de schakel tusschen heden en morgen' ('the link between today and tomorrow'), the Nacht Expres was slightly slower than the day train, with an average speed of 60 km/h. It was, however, more comfortable and free of the infernal heat of the tropical sun.

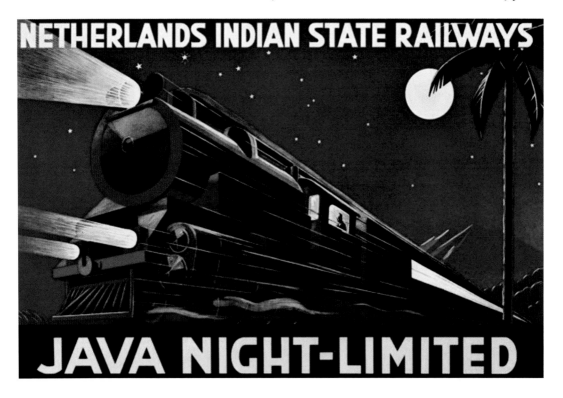

The Golden Chersonese (in Greek, Χρυσῆ Χερσόνησος) is translated into The Golden Peninsula, the name used for the Malay Peninsula by Greek and Roman geographers in classical antiquity. This 1933 travel poster advertises the Federated Malay States Railways, representing the European colonial vision of linking all of the colonies, in this case by train. It was produced a year after the Governor of the Straits Settlements, Sir Cecil Clementi, inaugurated a new terminal in Singapore. Speaking at the event, Sir Clementi stated that he stood at the end of a chain of railways which would one day form a continuous line from Britain to Turkey, Mesopotamia, Persia, India, Siam and Malaya. The poster was the work of Hugh Morton Le Fleming, a railway engineer who worked as an inspector for the Crown Agents for the Colonies. A photographer and artist, some of his pictures appeared in FMSR promotional material.

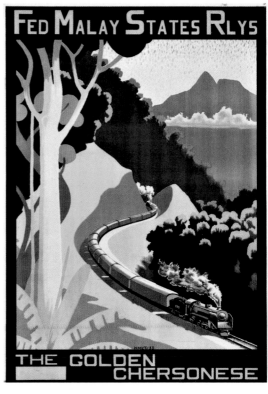

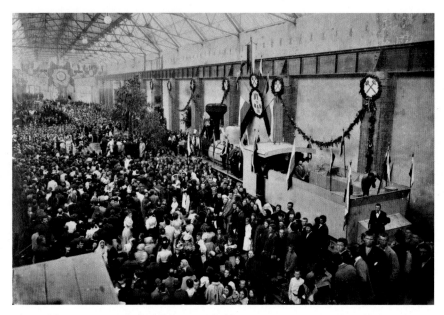

The public ceremony in this photo was held over a century ago, but eerily seems as though it had taken place only recently. On 28 May 1900, in a fully packed hall, Russian Orthodox priests officially bless the first steam locomotive manufactured at the Lugansk Locomotive Works in the Ukraine. The works were founded in 1896 as Russische Maschinenbaugesellschaft Hartmann, and renamed 'Locomotive Factory October Revolution' in 1918. The plant has since then produced thousands of type M62 and TE109 'Ludmilla' type diesel locomotives for eastern European railway companies.

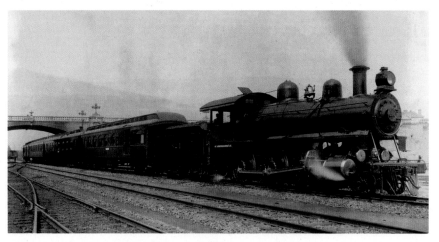

The South Manchurian Railway was built to connect the towns of Lüshun (Port Arthur) and Dalian, on the Liaodong Peninsula, with the Chinese Eastern Railway. This railway ran across north-eastern China and Siberia to the Russian seaport of Vladivostok. This final photo shows what has been described as the finest train in the Far East, connecting with the Trans-Siberian Railway at Harbin. South Manchurian Railway Class TH1 steam locomotive Nr. 624 was built by Alco of Schenectady in 1912, and carried the works number 50773. It is seen coupled to four clerestory coaches forming the South Manchurian Express.